IMAGES
of America

FIVE POINTS
NEIGHBORHOOD
OF DENVER

Cover Image: Bathing beauties stop to pose for a photo during a parade in Five Points. The young women proudly wear the ribbons of some of the most important and historical businesses in the community. Among them are Miss Rossonian, Miss Roxy Theater, Miss Deep Rock Water, Miss Granberry Mortuary, Miss Atlas Drugs, Miss Da-Nite, and others who represented the thriving Five Points business district during its heyday. At one time, the Five Points business district along Welton Street was the largest African American owned business community in the west. (Courtesy Denver Public Library, African American Research Library, Otha Rice Collection.)

IMAGES
of America

FIVE POINTS NEIGHBORHOOD OF DENVER

Laura M. Mauck

ARCADIA

First Printed 2001.
Reprinted 2002.

Published by Arcadia Publishing,
an imprint of Tempus Publishing, Inc.
3047 N. Lincoln Ave., Suite 410
Chicago, IL 60657

Printed in Great Britain.

Library of Congress Catalog Card Number: 2001088811

For all general information contact Arcadia Publishing at:
Telephone 843-853-2070
Fax 843-853-0044
E-Mail sales@arcadiapublishing.com

For customer service and orders:
Toll-Free 1-888-313-2665

Visit us on the internet at http://www.arcadiapublishing.com

CONTENTS

ACKNOWLEDGMENTS

To my parents for showing me the beauty and history of Colorado. And to Jeff who shared my dream of living here.

Special thanks also to Gwendolyn Crenshaw and Charleszine Nelson of the Denver Public Library's African American Research Library for their knowledge, support, and friendship throughout this project.

INTRODUCTION

In the 1870s, the word was out about Colorado. East Coast and Midwest prospectors, European immigrants and African Americans newly freed from slavery, rushed to Denver to find work and their fortune in silver and gold. Denver seemed to be the perfect place to begin a new life and African Americans, escaping the oppression and racism of the post Civil War South, found work laying track for the railroad companies. The completion of the Denver Pacific and Kansas Pacific rail lines in 1870 enabled Denver to become a major trade center for the west. The small town along the Platte River quickly became the third largest city in the west. By 1890 Denver had a population of 106,713. This number was smaller than San Francisco and Omaha, but larger than Los Angeles, Seattle, Phoenix, or any town in Texas.

In the late 1800s downtown Denver was a dusty, rough and tumble town. Five Points was one of the city's first subdivided parcels described as "far away from the city in the wide open prairie." Typical of the growth pattern of many other cities, the Five Points area was initially white with a large German, Irish, and Jewish population. It was named in 1881 for the five-way intersection of Welton Street, 27th Avenue, Washington Street, and 26th Street. The Curtis Park district, which is within the Five Points area, was considered the most elegant streetcar suburb in Denver in the 1880s. It offered those with the means to move out of the city an escape to the peaceful tree lined suburbs that boasted the city's first public park.

As the wealthy moved on to more prominent neighborhoods such as Capitol Hill to the south, African Americans began to move into the area. Prior to the 1890s, African Americans were scattered throughout the city. But as Denver's population grew, the area known as Five Points became the heart of the black community. Seeking proximity to their work at such places as the industrial plants and rail yards near the Platte River to the north of the neighborhood, the African American population began to increase in the area. In 1890, the U.S. Census reported that about 6,000 African Americans lived in Colorado, with about 5,000 of those owning property. Of those 6,000 people, 3,254 lived in Denver. African American churches such as Zion Baptist and Shorter AME were being constructed in the area in the late 1880s and early 1890s. In 1893, Fire Station No. 3, located in the center of the Five Points neighborhood, became the first all African American fire station in Denver. In the late 1890s, more African Americans lived in Five Points than any other part of the city. By the early 1900s restrictive housing covenants and segregation forced African Americans to stay in the Five Points neighborhood. For African Americans in Denver and throughout Colorado, Five Points became a city within the city. People in the community even remember receiving mail addressed to "Five Points, Colorado."

Founded in 1904, the Colorado Federation of Colored Women's Clubs chose as their motto "To the Stars, Through Difficulties." This quote seems to sum up the numerous historical

triumphs of African Americans in the Five Points neighborhood. The community nurtured the entrepreneurial, creative, and persevering spirits of the people who lived and worked there. For instance, Madam CJ Walker, who lived in Five Points and developed her hair products business there, became the United States' first woman millionaire. Dr. Justina Ford, Denver's first African-American woman doctor, opened her own gynecology, obstetrics, and pediatrics office in Five Points when discrimination would not allow her to practice in public hospitals. During the era of segregation, the thriving retail and commercial district along Welton Street helped to provide not only jobs, but also education and skills to many African Americans who otherwise would not have been given that opportunity. During the Depression, philanthropic efforts of citizens such as Benny Hooper helped to create a sense of hope for the community. Musical history was made in the neighborhood as well. In the 1930s and 1940s, Five Points was considered a requisite stop for world famous performers traveling between the Midwest and West Coast. Artists such as Count Basie, Lionel Hampton, Duke Ellington, Billie Holiday, and Ella Fitzgerald could be seen performing at the Rossonian to sold out crowds. Music would fill the air all night as jazz musicians played at after hours clubs such as the Casino Ballroom and Lil's.

When African-American soldiers returned home after World War II, they hoped to find acceptance and equal rights in exchange for serving their country. However, they found that not much had changed while they were away. African Americans were still not welcome in restaurants, hotels, theaters, and clubs in downtown Denver. Once again the African-American community, centering around Five Points, banned together. Groups such as the NAACP and CORE (Committee on Racial Equality) worked toward civil rights while the Urban League set the goal of better jobs for African Americans. In the midst of this controversy, or perhaps because of it, the business, social, and cultural scene in Five Points continued to thrive throughout the 1940s and 50s. Westerners often compared Five Points to Harlem. In response to segregation that soldiers faced, Benny Hooper opened the Ex-Servicemen's Club for African American Soldiers to call their own. The Rossonian continued its sold out performances, with patrons waiting in lines that stretched outside and down Welton Street. Ironically, at the height of the Rossonian's popularity, there were more white patrons at the club than African Americans because most neighborhood people couldn't afford the cover price to get in.

The lifting of restrictive real estate covenants in 1959 and again in 1965, prompted African Americans to join in the post war American dream of moving to the suburbs. Taking advantage of an opportunity that was not previously available, African Americans left the aging housing stock in Five Points for the new houses of places such as Aurora. The neighborhood began to see a dramatic decrease in population, which in turn had an effect on the housing and businesses in the area. Urban renewal projects in the 1960s tore down whole blocks of old houses, which were replaced with public housing. The neighborhood continued to decline throughout the 1980s.

Today new housing and commercial developments, as well as renovation projects, are breathing new life back into the neighborhood. People who want to experience urban living are moving into Five Points from the suburbs and the historic housing stock is slowly being renovated. Commercial revitalization can be seen in the form of new office buildings and retail space. Five Points is well on its way to becoming the thriving residential, commercial, and cultural community that it once was.

One

BIRTH
(1870–1880)

THE ARRIVAL OF RAILROADS, INDUSTRY,
AND STREETCARS

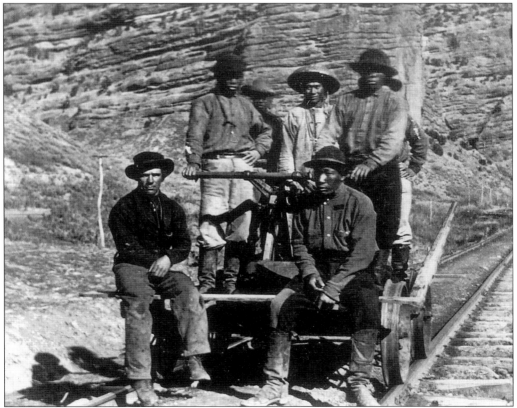

After the Civil War, freed slaves came west from the south looking for work. As railroad companies expanded from the East Coast to the West, many African Americans were employed as laborers laying track. The Denver Pacific Rail line was completed in June 1870 and the Kansas Pacific line was completed shortly there after. This enabled Denver to become a major trade center for the west. This photo shows workers building the Union Pacific line. (Courtesy Denver Public Library, Western History Department.)

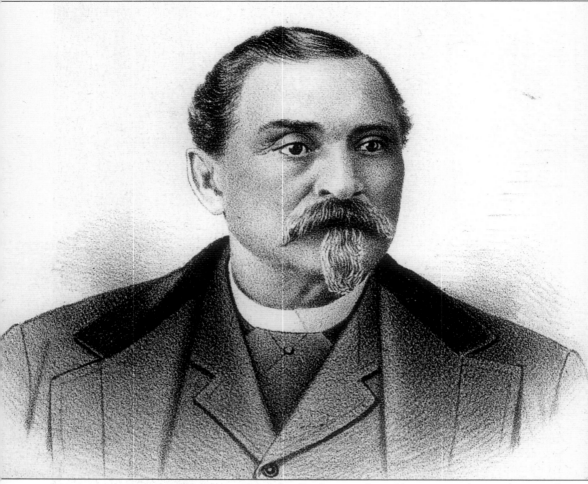

Born into slavery in 1822, Barney Lancelot Ford escaped to Chicago via the Underground Railroad. In 1860, Ford arrived in Colorado and began his career as a prosperous and popular innkeeper with the opening of the Ford's and Inter-Ocean Hotel in the lower downtown district of Denver. Ford helped his fellow African Americans by establishing literacy classes and by fighting the establishment of Colorado statehood until blacks were given the right to vote. Ford served with William N. Byers (founding editor of *The Rocky Mountain News*) and John Evans (Colorado territorial governor) on the board of the Dime Savings Bank and was a member of the Colorado Association of Pioneers. In 1898, he was the first African American in Colorado to make Denver's Social Register. Today, Barney Ford is immortalized in a stained-glass window at the Colorado State Capitol. (Courtesy Denver Public Library, Western History Department.)

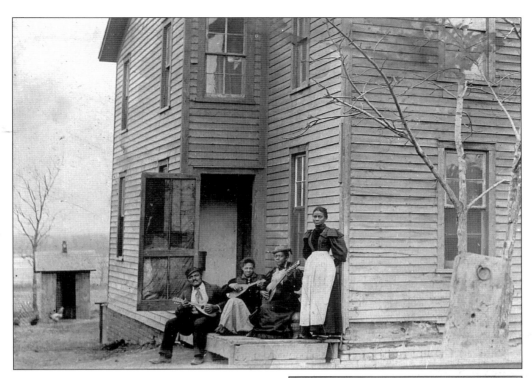

In the 1870s and 1880s the African-American population of Denver was dispersed throughout the city. It was not until the 1890s that Five Points began to develop as an African American community. In this photo from the 1880s a man and three women pose with mandolins and a guitar on the front porch of typical wood frame house in Denver. (Courtesy Denver Public Library, Western History Department.)

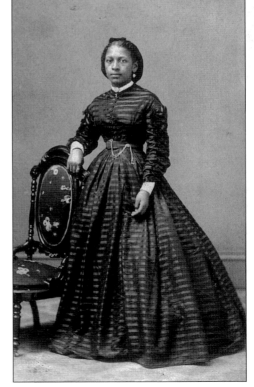

This portrait of Elsa A. Thomas, only identified as a "Denver Woman" on the back of the photo, was taken sometime in the 1870s. (Courtesy Denver Public Library, Western History Department.)

In the late 1870s and early 1880s, downtown Denver was considered a dusty, seedy place with brothels and taverns. Not many women would have been seen out in public in downtown at this time. The Wonderland Theater, located on Curtis Street, was known for its risqué features and wild sideshows. A Denver newspaper called the Wonderland Theater "one of the worst places in the city for indecent pictures." Siamese twins Millie and Christine were one of the shows at the Wonderland Theater. Handwritten on the back of this photo: "Wonderland Theater, Denver Freaks and Exhibits." (Courtesy Denver Public Library, Western History Department.)

The blacksmith shop in this photo from 1887 was located at 33rd Street and Walnut Street in Five Points. It was among many service-oriented businesses in the area that supported Denver as a major center not only for mining, but also for the cattle industry of the plains and the agricultural towns of the Platte and Arkansas River valleys. Written on the back of this photo, "Shod all horses for the Denver Fire Department. Conlan was also a veterinarian." (Courtesy Denver Public Library, Western History Department.)

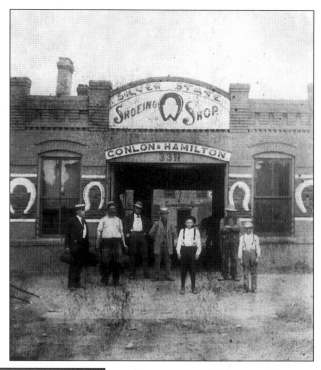

Before Max Kuner moved to Denver in 1872, his family had already established a long history of pickle manufacturing in cities such as St. Louis and Chicago. One year after moving to Denver, Max Kuner founded the Kuner Pickle Company on the west side of Denver. In 1885, the company was relocated to 22nd Street and Blake Street in the Five Points neighborhood. Max Kuner served as president of the company until his death in 1913. (Courtesy Denver Public Library, Western History Department, Rose & Hopkins Collection.)

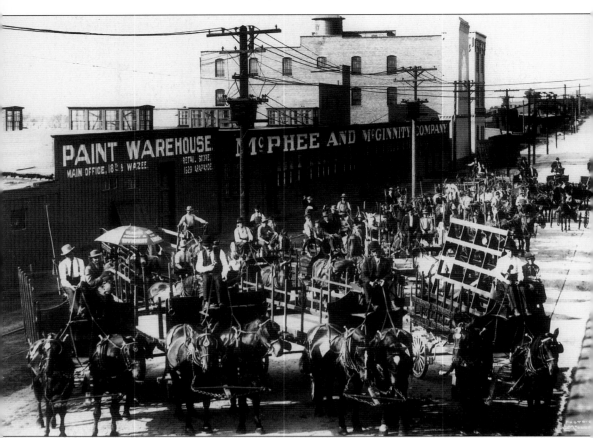

In the late 1880s the Five Points area was an important industrial, commercial, and service area for the city. Here employees of the McPhee-McGinnity Company are gathered together to pose on and around the company's horse-drawn wagons in front of the warehouse, which was located at 23rd Street and Blake Street. The company was founded in 1870, and for many years were makers and proprietors of building supplies such as paint, glass, nails, corrugated iron, and barbed wire. (Courtesy Denver Public Library, Western History Department.)

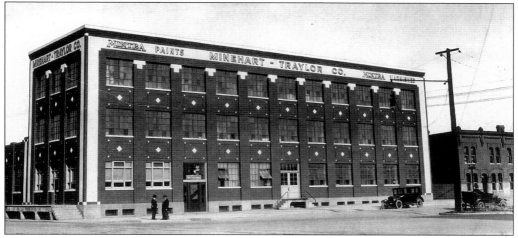

Another paint supply company in the Five Points area was the Minehart Traylor Company. It was located at the intersection of 25th Street, Walnut Street, and Broadway Avenue and was a manufacturer of Mintra paints and varnishes. (Courtesy Denver Public Library, Western History Department.)

Founded in 1876, the Denver Fire Clay Company initially manufactured fire resistant brick for the construction of smelters. After the mining industry started to slow down, the company became a major supplier of scientific instruments, chemicals, and clay goods that were used in laboratories. The building, which is located at 31st Street and Blake Street, still stands today and is being renovated into loft condominiums.

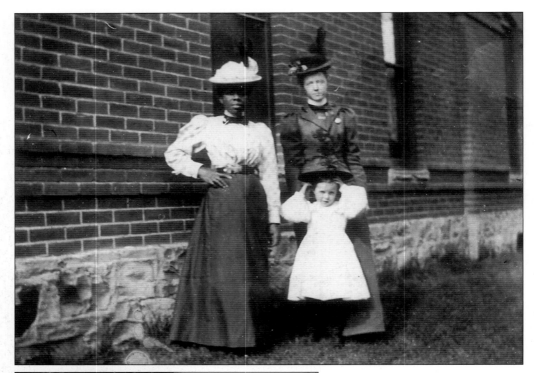

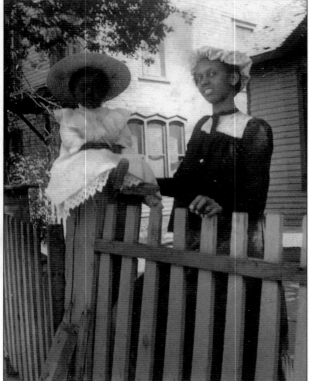

Mary Elizabeth Jones Holmes (wife of Dr. Clarence Holmes) poses with another woman and girl near what appears to be a church sometime in the late 1880s. The women are dressed in their Sunday best with high collars and feathered hats. One of Denver's African-American newspapers called Mrs. Holmes "one of Denver's leading women in club, social, church, and political circles." (Courtesy Denver Public Library, Western History Department.)

A mother balances her daughter on a fence in front of their house on Lafayette Street sometime in the 1880s. Handwritten on the back of the photo are the words "Fancy Dress." (Courtesy Denver Public Library, Western History Department.)

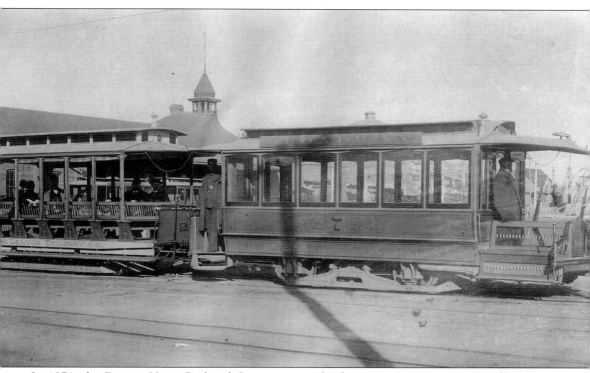

In 1871, the Denver Horse Railroad Company was the first to make connection to the Five Points area. The neighborhood was Denver's first streetcar suburb with connection from Auraria, through downtown, to the final destination of Five Points. In 1881, the Five Points name came to be used because the signs on the front of the streetcars weren't big enough to hold all of the street names. The intersection converged at 27th Street, Washington Street, East 26th Avenue, and Welton Street. Some residents in the area disliked the name because it was synonymous with the slum neighborhoods of the east. "Welton Center" was tried as an alternative name, but Five Points just seemed to stick. In 1886, Denver's first electric rail line was opened. The 15th Street line, which closed in 1888, ran in downtown Denver between Larimer and Tremont Streets. Although short lived, this line set the stage for a trolley system that would consist of 156 miles of electric track by 1900. This photo shows one of Denver's oldest electric powered streetcars, which was manufactured for the Denver Tramway Company sometime in the late 1880s. (Courtesy Denver Public Library, Western History Department, Harry Rhoads Collection.)

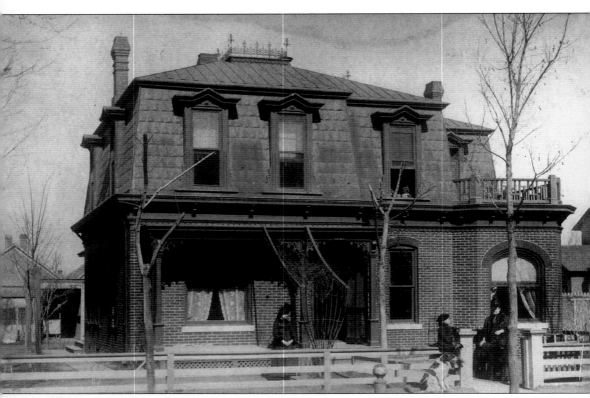

What would become known as the Five Points area was considered an elegant streetcar suburb in the late 1800s. In 1868 it boasted the city's first park, which was named after the pioneer Samuel Curtis. Because of its proximity to downtown and the convenience of the streetcar system the neighborhood began to develop very quickly. It was also known for its diversity, both economically and culturally, and it was not uncommon for upper middle class families to build next to those of lesser means. This photo, taken on March 8, 1888, is of the home of William M. Hastings, which was located at 2445 California Street in the Five Points neighborhood. Hastings was a clerk for the Denver and Rio Grand Railroad. The large house shows the presence of the upper middle class in the neighborhood at the time. (Courtesy Denver Public Library, Western History Department.)

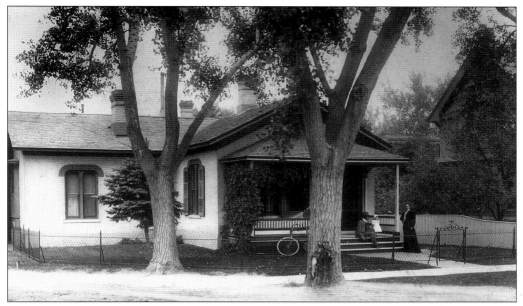

Far away from downtown in the "wide open prairie," the area that included Five Points was one of Denver's first subdivisions. As other parts of the city were still being subdivided, the Five Points neighborhood was growing and being developed with new homes. This home at 2045 Grant Street was the residence of Mr. and Mrs. Aaron Grove and their daughter Margaret, who pose on and near the front porch. This photo was taken sometime in the mid-1880s. (Courtesy Denver Public Library, Western History Department.)

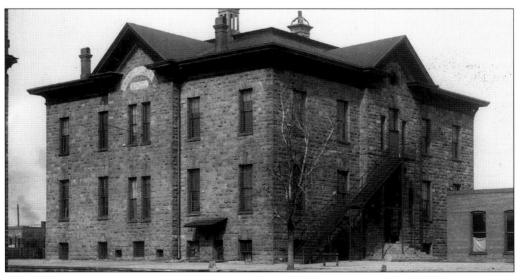

Colorado's first licensed architect, Robert Roeschlaub, designed the 24th Street School in 1879. It is believed to be the first stone school built in Denver and was constructed at 24th Street and Market Street. This school was attended by many of Denver's immigrant and minority children, whose families lived nearby. In testament to Five Points' social and economic diversity, it was noted that at one time, children from 37 different nationalities attended the school. (Courtesy Denver Public Library, Western History Department, L.C. McClure Collection.)

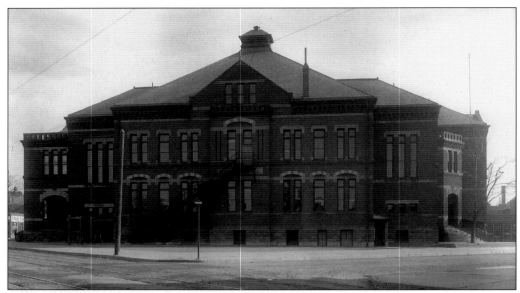

Robert Roeschlaub was selected to be the chief architect for the East Denver School District between the years of 1876 to 1889. Therefore, in addition to the 24th Street School, Roeschlaub also designed the Ebert School in 1880. Located at 22nd Street and Logan Street, the school was named after Frederick Ebert, who was one of the first developers of the Case and Ebert's addition of the Five Points area in 1868. (Courtesy Denver Public Library, Western History Department, L.C. McClure Collection.)

Shortly after Ebert School was built, Robert Roeschlaub designed Gilpin School in 1881. Gilpin School was located at the corner of 29th Street and Stout Street. The school was named after Colorado Territorial Governor William Gilpin. The original school was torn down in 1951 when a new school was built on 30th Street. (Courtesy Denver Public Library, Western History Department, L.C. McClure Collection.)

20

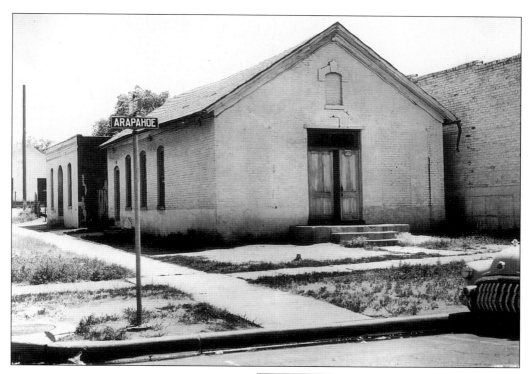

Founded in 1865 by ex-slaves, Zion Baptist Church is the oldest African American Church in Colorado. The original building was located at the corner of 20th Street and Arapahoe Street in Five Points, and was a log structure that was rebuilt in brick as it is seen in this photo. (Courtesy Denver Public Library, Western History Department, McCloud Collection.)

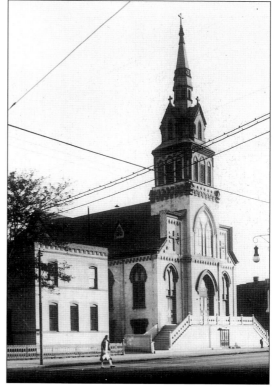

Denver's oldest functioning Catholic church, Sacred Heart Catholic Church, served Irish and Italian immigrants. Designed by Denver architect Emmet Anthony, this church and the Odd Fellows Hall in downtown are the only surviving examples of his work. In 1880 the church was built at 2760 Larimer Street. It quickly became one of the most prominent churches in Denver with such parishioners as the silver mining queen of Denver, Elizabeth "Baby Doe" Tabor. (Courtesy Denver Public Library, Western History Department.)

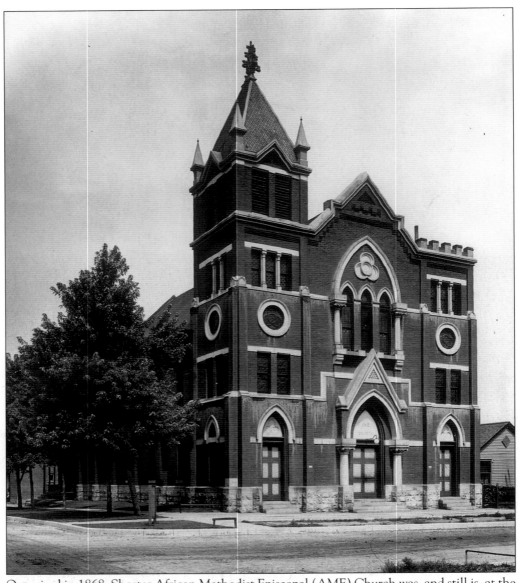

Organized in 1868, Shorter African Methodist Episcopal (AME) Church was, and still is, at the heart of the African American community in Denver. It is the one of the oldest African-American Churches in Denver. This is a photograph of the original Shorter AME Church, located at 23rd Street and Washington Street in the Five Points neighborhood. Built in 1888, this gothic revival style structure was destroyed by a fire in 1925, which was allegedly started by the Ku Klux Klan. (Courtesy Denver Public Library, Western History Department.)

Two

DEVELOPMENT
(1890–1900)

FIVE POINTS EMERGES AS AN
AFRICAN-AMERICAN NEIGHBORHOOD

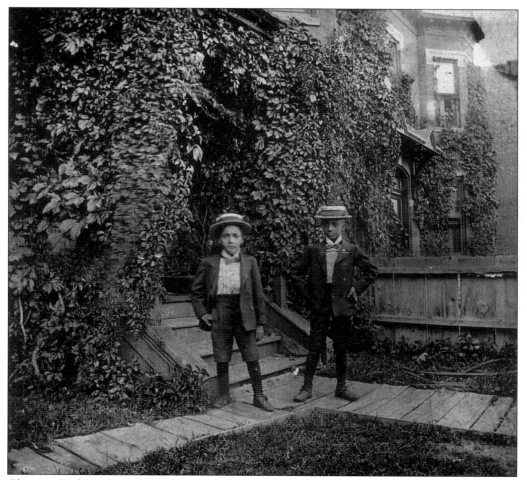

Clarence Holmes (at right) stands with a playmate in front of a home in Denver sometime in the 1890s. (Courtesy Denver Public Library, Western History Department.)

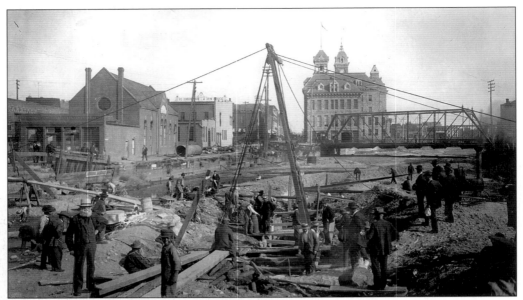

At the turn of the century, African Americans found work as laborers on many projects throughout Denver. This 1898 photo of the construction of the 14th Street Viaduct, shows a young African-American boy in the foreground pausing to smile for the camera as his co-workers go about their job. The Denver City Hall is in the background. (Courtesy Denver Public Library, Western History Department.)

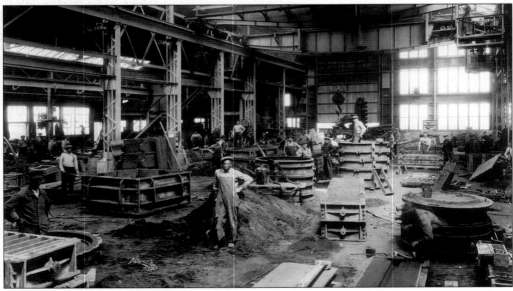

The Colorado Iron Works Company was a manufacturer of mining machinery, smelting furnaces, and architectural iron. The company was established in 1860 and incorporated in 1876. The Denver plant was located at 33rd Street and Wynkoop Street, but the company also had branches in Chicago and Mexico City. It was the largest iron works company between St. Louis and San Francisco. This interior photo, taken sometime in the late 1800s, shows working conditions at the time. (Courtesy Denver Public Library, Western History Department.)

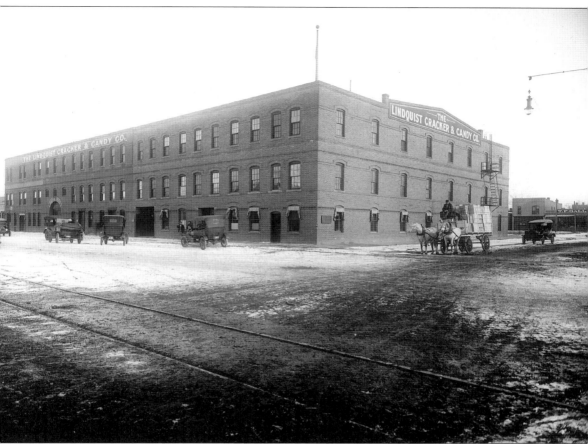

The Lindquist Cracker and Candy Company was located at 3512 Walnut Street. Lindquist Cracker and Candy was the only union cracker company between Chicago and the Pacific coast. In business from 1891 until 1929, the company used workers from the Local 26 Journeymen Bakers and Confectioners Union. The owner and founder of the company, Mr. E.J. Lindquist, fought against the National Biscuit Company (Nabisco), also called the "Cracker Trust," for many years regarding use of the name "Saratoga Flakes" for his crackers. He also fought Nabisco's many attempts to take over the Colorado company, and even changed the name to the Lindquist Anti-Trust Cracker Company sometime at the turn of the century. Local newspapers urged consumers to buy Lindquist Crackers to support a Colorado owned and operated company, and to stand up against the monopoly of Nabisco. (Courtesy Denver Public Library, Western History Department.)

S.T. Kostitch founded Deep Rock Artesian Water and Bottling Company in 1898. Today, the company remains an important part of the Five Points neighborhood, and continues to supply bottled water to Denver businesses and homes from its artesian well at the company's original location of 27th Street and Welton Street.

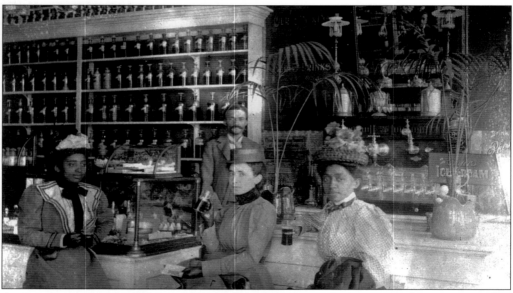

An interior view of the White and McMahon drugstore, soda fountain and ice cream parlor, which was located at 21st Street and Larimer Street in the Five Points area. Apothecary bottles line the walls and the women are dressed in the typical style of the late 1800s. On the upper right corner of the photo, a portrait of an African-American man hangs above the bar with flowers surrounding it. (Courtesy Denver Public Library, Western History Department.)

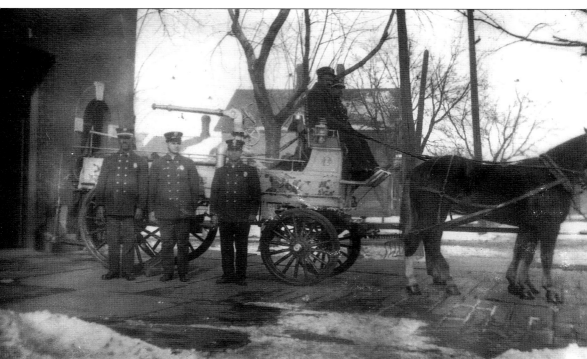

As more and more people moved into the Five Points area, public facilities were constructed to accommodate the growth. Located at 2563 Glenarm Place, Fire Station No. 3 was the first African-American Fire Company in Denver. Built by the city in 1888, it was originally managed by an all-white company. In 1893, it became an African-American company but was still under the command of a white fire chief. In 1895, four African-American firemen lost their lives fighting a hotel fire. This photo, taken in 1907, shows firemen posing by and atop a horse drawn fire engine. Captain Biffle stands to the far left. The building still stands today and is occupied by the Wallace Simpson American Legion Post. (Courtesy Denver Public Library, Western History Department.)

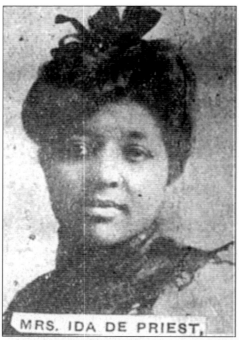

MRS. IDA DE PRIEST,

In 1894, clubwoman Ida DePriest and a few other "High Souled Women" formed the Colored Women's League of Denver under the National Association of Colored Women's Clubs. The club's motto, "Lifting as We Climb," was reflected in its members' commitment to provide community services such as educational support for African-American children during a time when such things were not always available. (Courtesy Denver Public Library, African American Research Library, Paul Stewart Collection.)

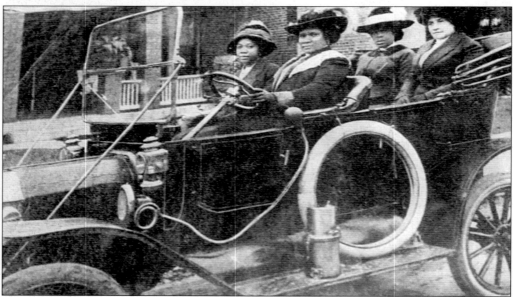

Born Sarah Breedlove in 1867 on a Louisiana plantation, Madam C.J. Walker (driver's seat) was America's first woman millionaire. In 1905 she moved to Denver to sell hair products for the Pope-Turnbo Company. After marrying Charles Joseph Walker, she developed her own line of products from their home in Five Points and eventually opened a parlor at 2317 Lawrence Street. In 1910, she moved the business to Indianapolis, where her factory employed hundreds of African Americans in the making of such products as "Madam CJ Walker's Wonderful Hair Grower." (Courtesy Denver Public Library, African American Research Library, Paul Stewart Collection.)

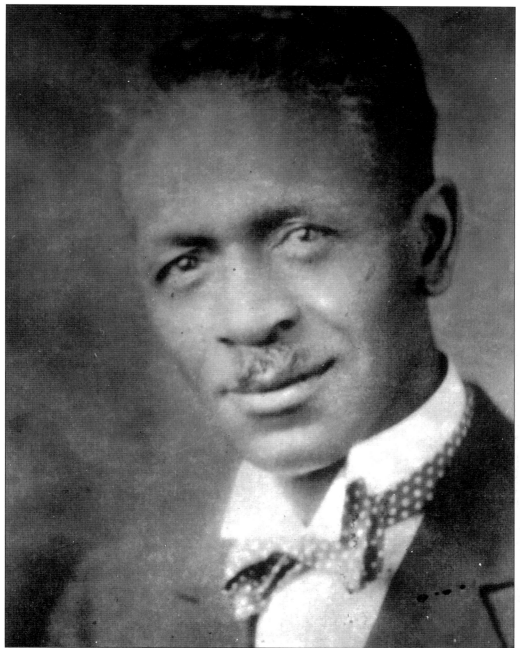

Ernest McClain was Colorado's first African American licensed dentist. He earned his license to practice in 1907 after attending dental school in Nashville, Tennessee at Meharry Dental School. He came to Denver with two prominent African American physicians, Dr. J.H.P Westbrook and Dr. J.A. Harper. Throughout his career, McClain had an office in Five Points as well as other locations in Denver. Dr. McClain was a member of Zion Baptist Church, the Masons, and the Mountain Lodge of Elks No.39 of Denver. He retired from his dental practice in 1948. (Courtesy Denver Public Library, African American Research Library.)

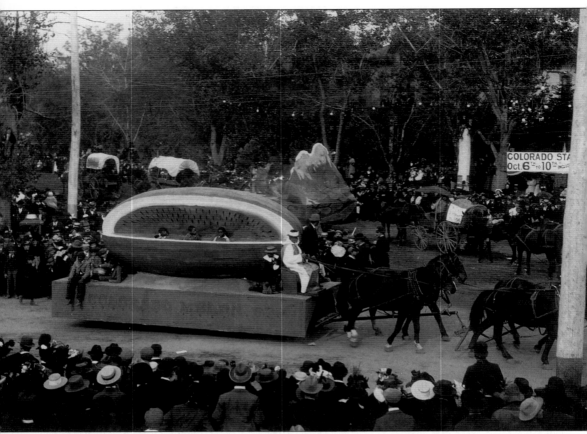

In 1895, the Festival of Mountain and Plain was created as a celebration to commemorate the end of the Silver Crash. It recognized Colorado's other assets such as agriculture, livestock, and the many resources provided by the mountains. The Festival was a Mardi Gras-like celebration that lasted a week and included parades, fireworks, and other celebrations. In celebration of the state's successful agricultural industry, this float represents the watermelon crop in Colorado. This photo was taken in 1896, during the 2nd annual Festival of Mountain and Plain parade. Riding in the watermelon-shaped float are young African American children who are supposed to represent the seeds. (Courtesy Denver Public Library, Western History Department.)

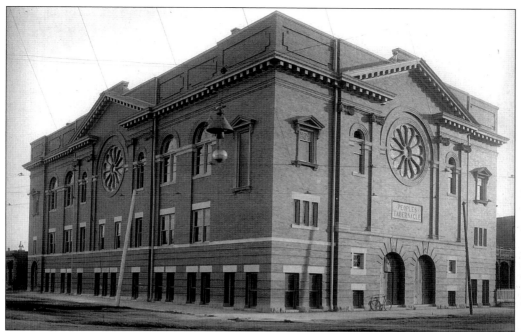

In the late 1800s, Five Points was the earliest area of Jewish settlement in Denver. This photo of People's Tabernacle, built in 1901, shows the presence of the Jewish community in the neighborhood. Located at 20th and Welton Streets, the building also included public baths, reading rooms, and an employment bureau. (Courtesy Denver Public Library, Western History Department, Joseph Collier Collection.)

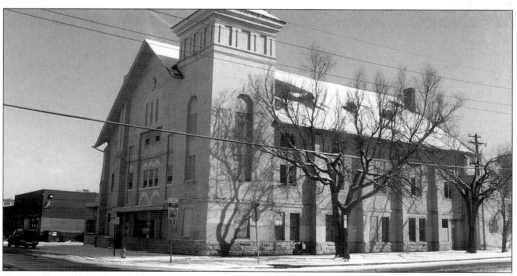

Originally called the Hebrew Burial and Prayer Society, Temple Emanuel was organized in 1873. In 1882, the building in this photo was erected at the corner of 24th Street and Curtis Street. Although the congregation moved again in 1899 to a new location at 16th Street and Pearl Street, the Curtis Street Temple is still standing and is listed on the National Register of Historic Places. (Courtesy Denver Public Library, Western History Department.)

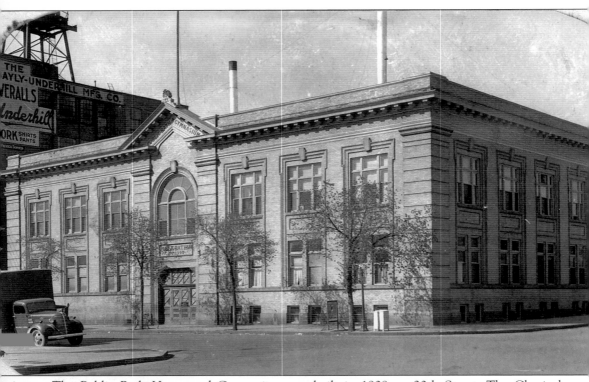

The Public Bath House and Gymnasium was built in 1908 on 20th Street. The Classical Revival-style building was constructed by the city with the intention of serving Denver's poor, whose homes usually did not have running water. The building included a gymnasium, bathing facilities, swimming pool, and sinks for laundry. Although it was built in the Five Points neighborhood, African Americans still faced segregation at this public building. They were only allowed to use the pool on the days before it was going to be cleaned. (Courtesy Denver Public Library, Western History Department.)

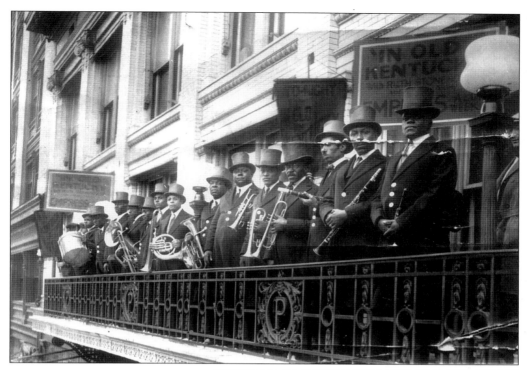

At the turn of the century, musical groups from the East Coast, Midwest, and the South toured the country performing jazz. In this photo, an African-American jazz group stands ready to perform on the balcony of the Empress Theater on Curtis Street in downtown Denver. (Courtesy Denver Public Library, Western History Department.)

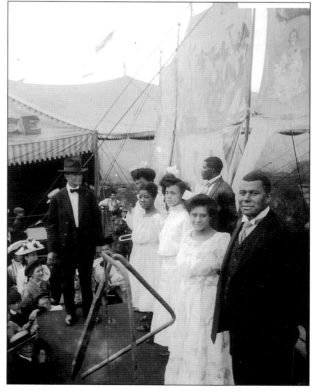

Denver was a common stop not only for jazz groups, but also for many types of traveling shows on their way to the west coast. In this photo, a singing group called the Georgia Minstrels performs for the crowd at the Wallace Brothers Circus. (Courtesy Denver Public Library, Western History Department.)

Before Mayor Robert Speer took office in 1904, Denver was a dusty, treeless town on the high plains. Through his City Beautiful Plan (a movement that was popular among major cities such as Chicago, Boston, and New York) Mayor Speer transformed Denver into the "Paris on the Platte." His plan would change the heart of the city into the Civic Center Park and government office complex, and double the city's park space. New boulevards and parkways were a major part of Denver's new look. Infrastructure improvements such as laying sewer and water lines, paving streets, installing sidewalks, and upgrading city services were also essential to his plan. Under Speer's leadership, the city built the Denver Museum of Natural History, Denver Zoological Gardens, Denver Art Museum, and the new central library with several branches. Speer was mayor from 1904–1912 and was re-elected again from 1916–1918. (Courtesy Denver Public Library, Western History Department, Harry Rhoads Collection.)

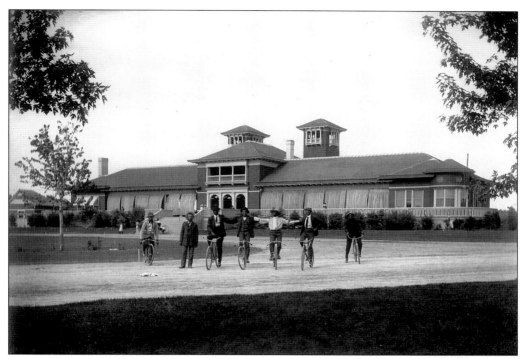

City Park is Denver's largest, most elaborate park and is home to many of Mayor Speer's projects such as the Museum of Natural History and the Denver Zoo. Harry Meryweather, a city civil engineer, patterned the park after Central Park in New York. He used a romantic, informal plan of looping drives and walks that lead visitors through grassy expanses, dense tree plantings, and past serene lakes. In this photo from around 1910, African American men take a moment to pose for a photo while bicycling around the park. (Courtesy Denver Public Library, Western History Department.)

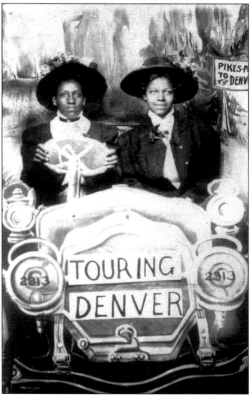

Mayor Speer also promoted Denver as a tourist destination. In this photo, Lulu Fisher (left) and Donna Nelson (right) pose for a picture postcard in a prop car that reads "Touring Denver" on the grille. Not only was the promotion of the city important, but also the beautiful mountain country that lay outside its borders. A sign that reads "Pikes Peak to Denver" is painted on the backdrop showing the importance and popularity of mountain tourism. (Courtesy Denver Public Library, Western History Department.)

Central Baptist Church was founded in 1891 when a small group left Zion Baptist Church under the leadership of W.P.T Jones. At first, the congregation rented the Old Campbell A.M.E. Church at 23rd and Larimer Streets. Then in 1911, the congregation purchased land at the corner of 24th and California Streets. In 1912 excavation of the basement began and by 1916 the cornerstone was laid. Improvements to the building continued throughout the 1920s, including the addition of an auditorium in 1925.

As Five Points began to develop more as an African-American neighborhood the railroads remained an important part of the community. This photo from the early 1900s is of the 23rd Street Viaduct that passed over the rail yards in Five Points. (Courtesy Denver Public Library, Western History Department.)

Three
STABILIZATION (1910–1920)
THE FIVE POINTS COMMUNITY BECOMES MORE UNIFIED

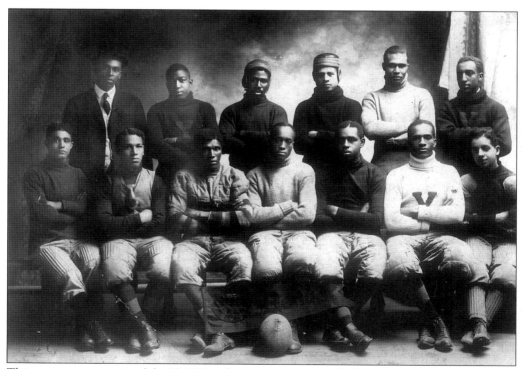

This is a group portrait of the YMCA African-American football team in the 1910s. Clarence Holmes (top row right) and William E. Parks (top row left) were members of the team. The banner at their feet reads Denver and has the YMCA symbol. (Courtesy Denver Public Library, Western History Department.)

In 1911, Zion Baptist Church agreed to buy the 1893 building that originally belonged to Calvary Baptist Church. In 1913, Zion Baptist moved into the building at 933 East 24th Avenue and quickly became the largest African American church in Denver. It is believed that Calvary Baptist Church wanted to move out of the neighborhood when the African American population began to increase. (Courtesy Denver Public Library, Western History Department, McCloud Collection.)

"To the stars through difficulties" was the motto of the Colorado Federation of Colored Women's Clubs, which was founded in 1904 by Elizabeth Ensley. In 1916, the Federation founded the George Washington Carver Day Nursery. The nursery, located at 2337 Clarkson Street, offered nursery services to low-income families and mothers at a low cost for children of all races from the ages of 6 months to 12 years. (Courtesy Denver Public Library, African American Research Library, Paul Stewart Collection.)

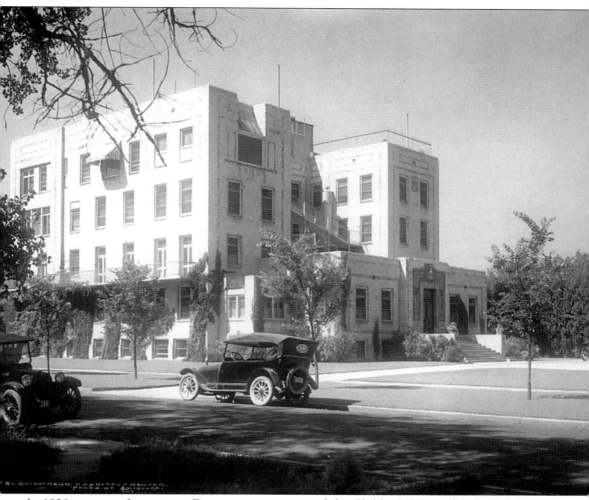

In 1906, a group of prominent Denver women organized the Children's Hospital Association in order to raise money to fund a much needed permanent hospital for Denver's children. Located at 2221 Downing Street, the Children's Hospital was opened in 1910 in a converted house. The facility accepted patients without regard to race or ability to pay. The hospital was so successful that it exceeded its patient capacity in seven years. In 1917, a new building at 1056 East 19th Street, seen in this photo, was constructed. Today the Children's Hospital is ranked fourth in the country for hospitals that care for children. The hospital has more than 1,000 pediatric specialists and 1,800 full-time employees. It provides care to the region's children at its main campus, and through three specialty-physicians satellite offices, four community-based urgent and emergency care sites, and more than 400 outreach clinics held annually in a seven-state region. (Courtesy Denver Public Library, Western History Department, L.C. McClure Collection.)

Affectionately known by her patients as "The Lady Doctor," Dr. Ford specialized in gynecology, obstetrics, and pediatrics. Denied hospital privileges for many years, Dr. Ford's determination to bring medical service to the disadvantaged of Denver resulted in the establishment of her home practice and office in the Five Points neighborhood. Throughout her career, which spanned a time period from 1902–1952, Dr. Ford faced the obstacles of being both African American and female in a profession that most people thought should belong to white men. A few months before her death in 1952, Dr. Ford was quoted to say, "When all the fears, hate, and even some death is over, we will really be brothers as God intended us to be in this land. This I believe. For this I have worked all my life." (Courtesy Paul Stewart Collection.)

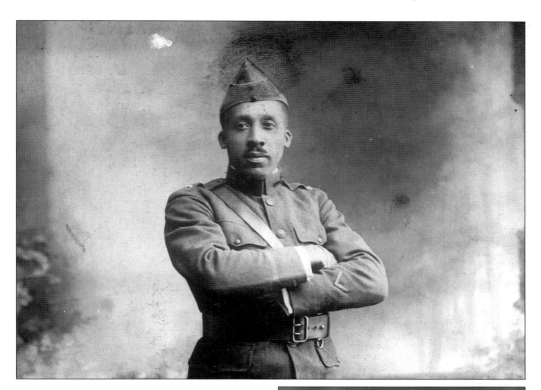

In 1917, Earl Mann was one of the first men to be commissioned from the Negro Officers School during World War I. During the war, Mann served in France. He was also a Colorado State Representative for five terms and helped to bring equal rights to African Americans with bills that enforced such things as fair employment practices. (Courtesy Denver Public Library, African American Research Library, Paul Stewart Collection.)

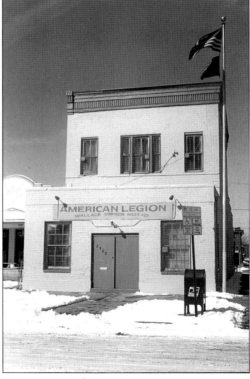

After World War I, Frederick Perkins saw a need to establish an African-American post of the American Legion in Denver. In 1919, the Wallace Simpson American Legion Post No. 29 was established in Five Points. Perkins named the post after his friend Wallace Simpson, who was the first Colorado African American to die in World War I during the bombing of the *U.S.S. Jacob Jones.* The club is still active and is located in the old Fire Station No.3 at 2563 Glenarm Place.

Located at 27th Street and Franklin Street, Manual High School was the high school for the Five Points area. Because of the concentration of African Americans in the neighborhood by the 1920s about half of Denver's African-American high school population was enrolled at Manual High School. (Courtesy Denver Public Library, Western History Department, McCloud Collection.)

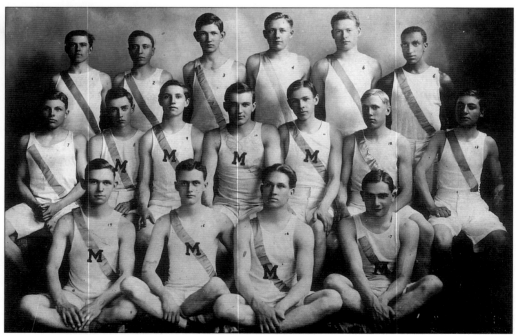

Clarence Holmes (top row far right) was the only African American on Manual High School's track team in the early 1910s. It was not until the 1920s that Manual's African American enrollment began to rise significantly. (Courtesy Denver Public Library, Western History Department, Holmes Collection.)

This is Clarence Holmes' graduation portrait from Manual Training High School in 1913. After graduation, Holmes went on to Howard University to study dentistry. (Courtesy Denver Public Library, Western History Department, Holmes Collection.)

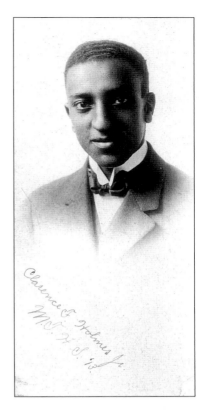

George W. Gross was the first president of the Denver Chapter of the National Association for the Advancement of Colored People (NAACP). With assistance from other prominent African Americans such as Clarence Holmes and *Denver Star* publisher and attorney George Ross, Gross founded the NAACP in 1915. The group's first action was to lead African Americans in protest against the showing of the pro-KKK film "Birth of a Nation" in Denver movie theaters. In 1925 the NAACP held their National Convention in Denver. (Courtesy Denver Public Library, African American Research Library, Paul Stewart Collection)

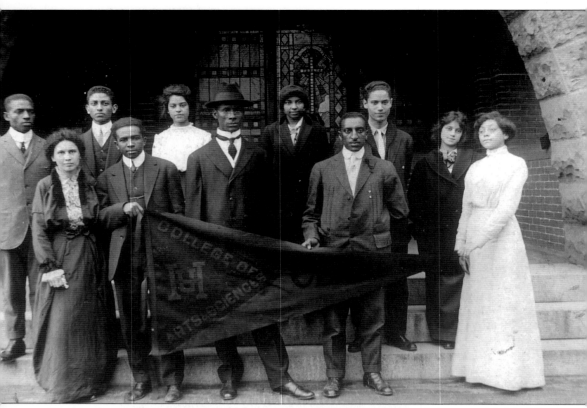

In this photo, Clarence Holmes (second from right, holding banner) is seen with his fellow classmates at graduation from Howard University in Washington D.C. The banner that is held by the students reads "HU College of Arts & Sciences." After his graduation in 1917 Holmes returned home to Denver in order to open his dental practice in Five Points. "Denver Boy Makes Good" was the headline of an article from a Denver newspaper regarding Dr. Holmes passing his Colorado Board of Dental Examiners exam. (Courtesy Denver Public Library, Western History Department, Holmes Collection.)

In 1910, Oliver T. Jackson founded the African-American farming community of Dearfield, Colorado. Jackson believed it was important for "our people to get back to the land, where we naturally belong, and to work out their own salvation from the land up." The community existed until 1953 when Jackson's niece, Jennie, was the last inhabitant to leave. Jackson was a messenger at the Colorado State Capitol, serving five governors, including Governor John Shafroth, who helped him realize his dream of Dearfield. (Courtesy Denver Public Library, Western History Department.)

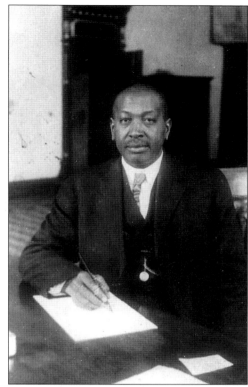

The original name of Dearfield was "Chapelto" as the name on the post office shows in this photograph. However, OT Jackson changed the name of the community to Dearfield because he believed that African Americans should hold it "dear" to their hearts. Although in poor condition, some of the buildings of Dearfield still stand. (Courtesy Denver Public Library, Western History Department.)

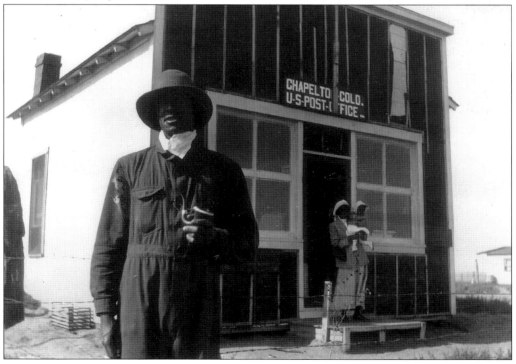

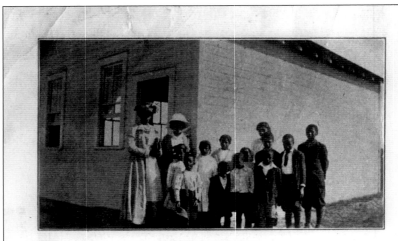

DEARFIELD PUBLIC SCHOOL

portunities of Colorado, such as no other state in the Union offers. At the rate the lands and resources of Colorado are being gobbled up by foreigners and southerners the last call will soon be heard. Shall we as a race delay until at last it is too late?

Dearfield Town Settlement has laid a great foundation for the building of the wealthiest Negro community in the world because of its productive soil, it climatic conditions, its close proximity to water, fuel, railroads, and the best market in the world which always has a demand for your product.

The accompanying table will give some idea of the development of this settlement:

How Dearfield Has Grown.

In 1910 the 20,000 acres now comprising the town of Dearfield and the surrounding agricultural settlement belonged to the U. S. Government.

State Land Board Appraisement.

Land value, 1917 at $15.00
 per acre............................$300,000
Town of Dearfield..............20,000
Town property...................2,500
60 settlers' improvements...60,000
Stock and crops, 1917........50,000
 ———
 Total...................$432,500

Valuation in 1910, at
 $1.25 an acre.................$25,000
Total assets of all settlers
 at beginning of
 settlement10,000
 ———
 Total for 1910.........$35,000
Net increase in valuation
 and assets in 10 years....$397,500

This is a remarkable showing for Colorado farmers of whom ninety percent had never lived on farms or had farming experience before coming to the state.

Now is the time for the young Negro to become interested in the town of Dearfield and be counted in its history as one of Dearfield's progrssive pioneers in business. To those who buy lots or tracts at once for business purposes we will give every inducement possible for WE NEED YOUR BUSINESS NOW to furnish the farmers with supplies and to handle their marketable crops. We want 100 families to build up the town of Dearfield.

References

Senator John F. Shafroth, Senate Chambers, Washington, D. C.

Ex-Governor Elias M. Ammons, 340 Gas & Elec. Bldg., Denver.

Ex-Governor George A. Carlson, Fort Collins, Colo.

A promotional brochure from 1917 for Dearfield proclaims the current and future successes of the agricultural community. "Productive soil, climatic conditions, close proximity to water, fuel, railroads and the best market in the world, which always has a demand for your product" are among some of the advantages to African Americans willing to invest in the farmland at Dearfield. In an attempt to reach their goal of "one hundred families to build up the town of Dearfield," the photo of a teacher and her students standing outside the school house shows that public education is available to children whose families chose to move to Dearfield. (Courtesy Denver Public Library, Western History Department.)

This advertisement from the Colored American Loan & Realty Company shows the three officers of the company from left to right: W.A. Jones, A.A. Walker, and H.J.M. Brown. The company, which was located in Five Points at 2636 Welton Street, sold land in Dearfield. The advertisement tells of how the business began under "unfavorable conditions" in 1901, but eventually became a successful business despite all of the challenges that came to it, and asks for the continued support of the African-American community. (Courtesy Denver Public Library, Western History Department.)

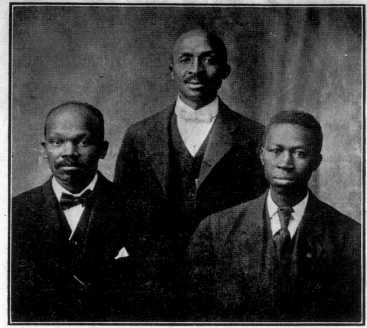

THE COLORED AMERICAN LOAN AND REALTY CO.

Began its existence under very unfavorable conditions on July 3, 1901. The first officers elected to manage this little project were W. A. Jones, M.D., Pres.; A. A. Waller, Secretary and H. J. M. Brown, Treasurer. This set of officers has served the company unchanged, during the life of the co-partnership. The small loan business grew so rapidly and extensively that we were compelled to add the Real Estate feature with A. A. Waller as manager.

An immediate death was predicted for this little adventure. First, because it was a wide diversion from the line of business heretofore engaged in by the Negro; second, we were forced into competition with men of the other race who had years of experience in this line of business, and capital in unlimited amounts at their command with which to successfully put through any deal they could match; third, the lack of vision on the part of the Negro, to see and know that if he would have a representative in any line of business that he above all else must give him his full support. We can say of a truth that after 17 years of sticking, that the light is beginning to dawn. And by staying in the game and refusing to quit regardless of cost or conditions, we have encouraged others to enter the various branches of business knowing that every one that enters make it easier for the next. This little Company began business with the small sum of $350.00. They now own City property, both improved and unimproved, a ranch and stock, and today they are doing about $4,000 worth of business each month. It is our aim to please all the people, and we stand as your representative in this line of business in this community, and our future success will depend very largely on you.

The Colored American
Loan & Realty Co.

2636 Welton Street Denver, Colo

PHONE CHAMPA 4 5 5

COPYRIGHTED 1909
PATIENTLY PROGRESSING

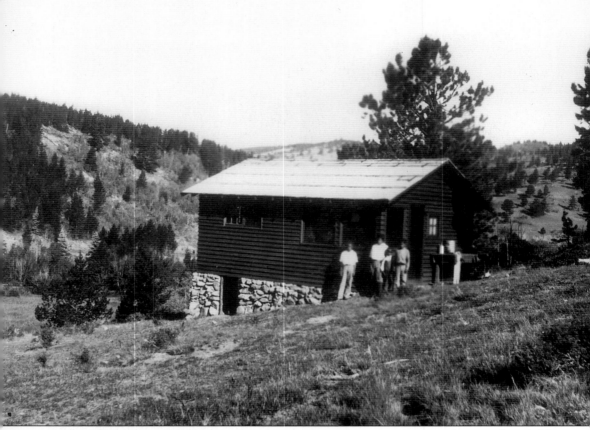

Lincoln Hills was an all African-American mountain resort community that was founded by Windell "Wink" Hamlet in the 1910s. Parcels of land were sold to African Americans from all over Colorado, and especially from Denver, for $5 down and $5 a month until a total of $50 was accrued. The community offered easy access from the city via the railroad as well as beautiful mountain views and a river running through the property. Windell Hamlet built Winks Lodge at Lincoln Hills, where he hosted many African-American celebrities that visited the resort community while vacationing in the mountains. Many of the cabins at Lincoln Hills still exist today, including Winks Lodge, and are privately owned. (Courtesy Denver Public Library, African American Research Library, Paul Stewart Collection.)

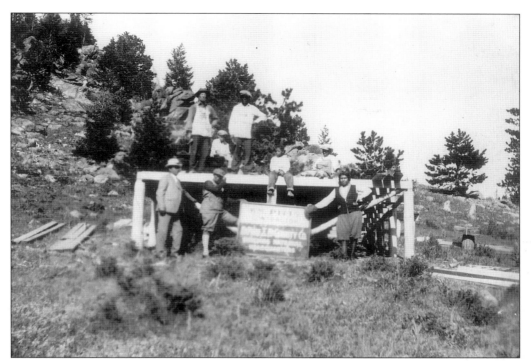

Property owners at Lincoln Hills often built their own cabins. Here a group pauses for a photo around a McPhee-McGinnity Building Supply sign during the construction of one of William Pitts' Cabin. McPhee-McGinnity was a Five Points based building supply company. (Courtesy Denver Public Library, African American Research Library, Paul Stewart Collection.)

Five Points residents would take the train from Moffat Depot in downtown Denver up to Lincoln Hills. This depot was used instead of the Union Station because, unlike the large passenger trains, this train went through Moffat tunnel on a narrow gauge rail up to the mountains. The building still stands today, but is abandoned.

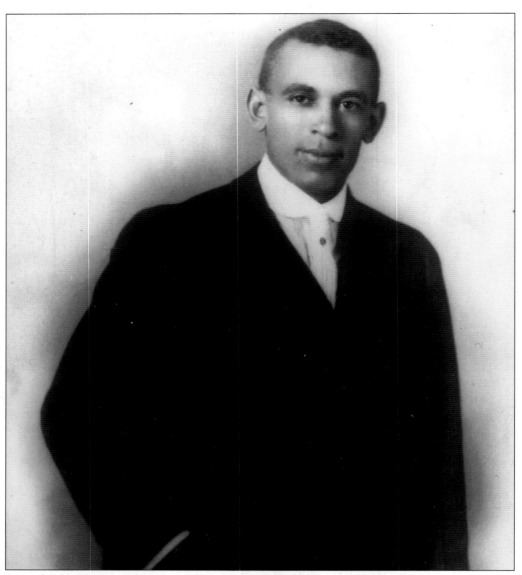

Samuel Eddy Cary was born on July 9, 1886, in Providence, Kentucky. The youngest of five children, Carey graduated from law school at Washburn University in Topeka, Kansas. He opened his first law office in Russell Springs, Kansas, where his long, colorful, and sometimes controversial career began. Cary, his wife, and two children moved to Denver in 1919 because he felt that a larger city would offer more opportunities. In that same year, Cary was admitted to the Colorado Bar, becoming the first African-American attorney licensed to practice in Colorado. Cary set up an office in Five Points and specialized in criminal law. In 1926, the Colorado Bar Association disbarred Cary on the grounds of "neglect and dereliction of duty in representation of his clients." It is believed that these accusations were false and put forth to the all-white Bar Association in order to disbar the successful and high profile black attorney. Cary's license was reinstated in 1935. In 1971, his name was honored with the founding of the Sam Carey Bar Association, which is a legal network of black attorneys throughout the United States. (Courtesy Denver Public Library, African American Research Library, Cary Family Collection.)

This portrait of Sam Cary's wife, Allena Barker Cary, was taken in the 1930s. (Courtesy Denver Public Library, African American Research Library, Cary Family Collection.)

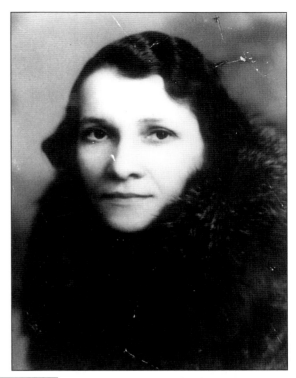

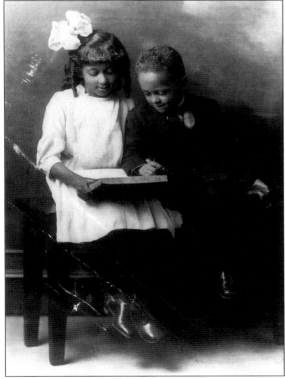

This portrait is of Sam and Allena's two children, which was taken in Denver in the early 1920s. Kathryn Eleanor was born in 1912, and John was born in 1915. (Courtesy Denver Public Library, African American Research Library, Cary Family Collection.)

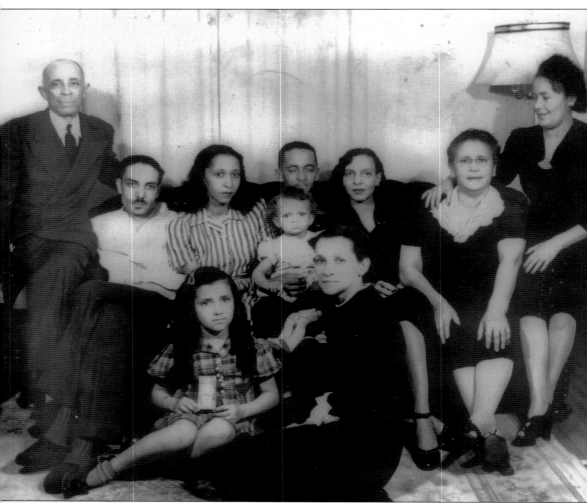

Sam Cary's family poses for a photo in 1942. His granddaughter Kaye holds a photo of Sam because he was in Kansas at the time the photo was taken. From left to right are: Curtis Cary (brother), Lawrence Parsons (son-in-law), Kathryn Cary Parsons (daughter), John Cary (son), Opal Cary (daughter-in-law), Velios Cary (granddaughter), Lena Cary (sister), Geneva Taylor (niece). Seated in front left to right are: Kaye Parsons (granddaughter) holding photo of Sam, and Allena Cary (wife). (Courtesy Denver Public Library, African American Research Library, Cary Family Collection.)

In the early 1900s, many Five Points residents were employed as waiters or porters by the railroad companies. This photo from the 1910s shows servants standing ready to serve customers in the dining car of a Denver and Rio Grande Train. (Courtesy Denver Public Library, Western History Department, George Beam Collection.)

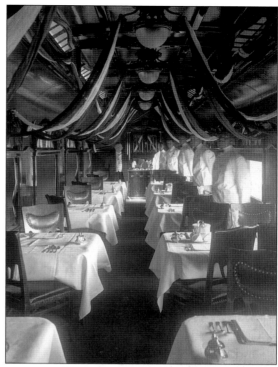

This photo of a cook on a Denver and Rio Grande Train was taken during the 1920s. However, a majority of African Americans struggled to find work that was not some kind of service position well into the 1950s. A quote from the 1940 Work Progress Administration's Writer's Program Colorado book describes Five Points: "North of Capitol Hill live the majority of the city's Negroes employed for the most part as laborers, porters and domestic servants." (Courtesy Denver Public Library, Western History Department, George Beam Collection.)

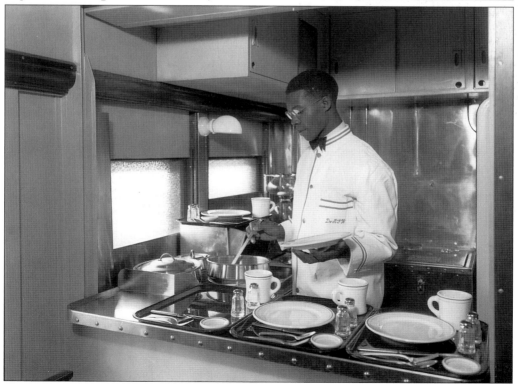

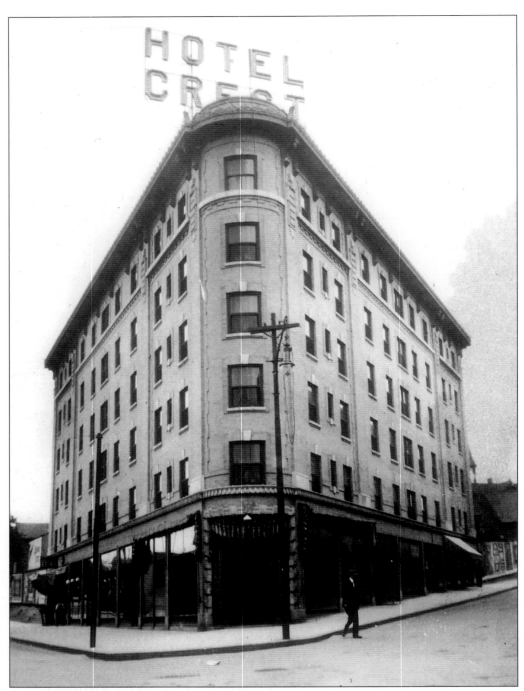

The Hotel Crest was located at the intersection of Welton Street, Broadway, and 20th Street. Mimicking the shape of the intersection, the beautiful flatiron building was completed in 1913. The last listing for the Hotel Crest in the Denver City Directory was in 1925. The building was demolished in the 1970s. A parking lot now occupies the space where it once stood. (Courtesy Denver Public Library, Western History Department.)

Four

PERSEVERANCE
(1920–1940)

THE BEST OF TIMES AND THE WORST OF TIMES

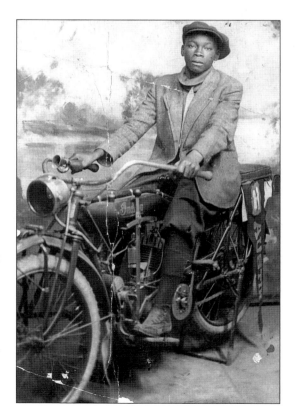

Otha Rice Sr. is seen here posing for a picture postcard on a motorcycle in the 1920s. The photo was probably taken in Austin, Texas, as indicated by the pennant on the bike. Otha Rice Sr. was a prominent business owner in Five Points who helped to bring the Texas tradition of celebrating Juneteenth to Five Points. The celebration commemorates June 19th 1865, which was the day that African Americans in Texas first heard the news of the Emancipation Proclamation. (Courtesy Denver Public Library, African American Research Library, Otha Rice Collection.)

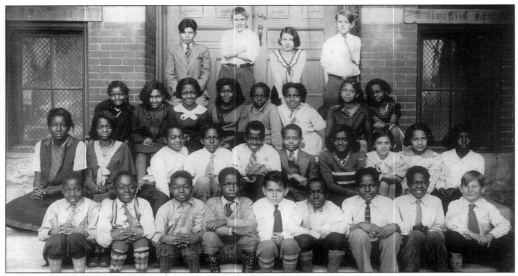

By the early 1890s more African Americans lived in Five Points than any other part of the city because of segregation and an increase in industrial jobs in the area. The "Great Migration" of 1916–1919 also had an effect on the population of Five Points. As African American's left the south to escape repressive laws such as the Jim Crow Laws, the black population rose. This photo of the fourth grade class at Whittier School shows that Five Points had almost completely transformed into an African-American neighborhood when it was taken in 1929. (Courtesy Denver Public Library, African American Research Library, Mosley Family Collection.)

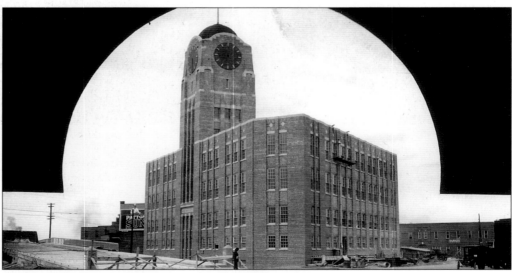

The Broadway Extension Project also impacted the development of Five Points as an African-American community. In the early 1920s the project extended Broadway from its terminus at East 20th Street to Blake Street. This plan created a direct route to the industrial area of Denver. However, many low-income African Americans living in the area were displaced and pushed further towards the Five Points intersection. In this foreground of this photo, construction of the Broadway Extension Project is seen in front of the McPhee-McGinnity building. (Courtesy Denver Public Library, Western History Department.)

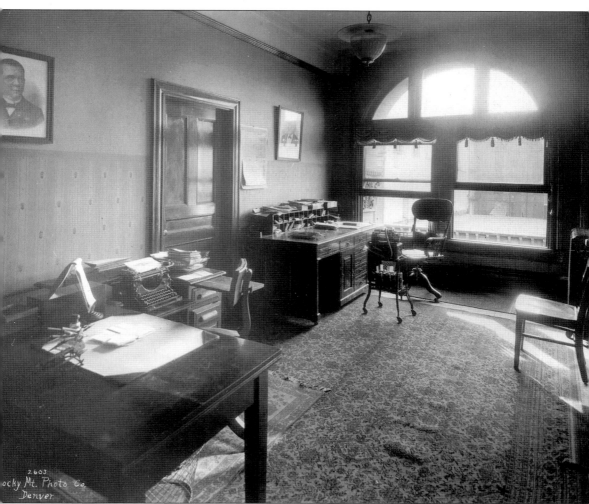

2.603
ocky Mt. Photo Co.
Denver.

Originally founded in 1901 by whites as a non-profit organization that would be a "fraternal benefit association for Negroes," the Supreme Camp of American Woodmen was quickly taken over by African Americans and turned into a corporation. The original offices for the American Woodmen Insurance Company were located in downtown Denver in the Arapahoe Building. This photo is of the old office sometime in the early 1920s, which was "two 8 by 12 foot rooms used by two employees, a stenographer and a clerk." (Courtesy Denver Public Library, Western History Department.)

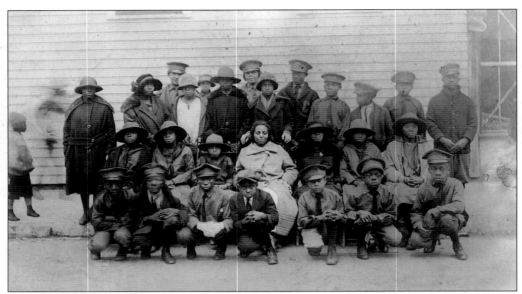

Young boys and girls from the Denver American Woodmen Juvenile Contingent pose for a photo in 1920. (Courtesy Denver Public Library, Western History Department.)

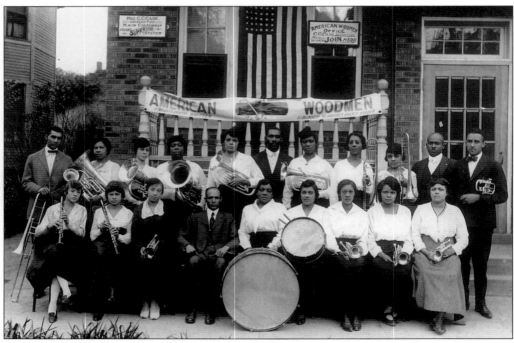

Leslie Lightner is often credited with the success of American Woodmen. When Lightner took over as Supreme Clerk of the company in 1911, its membership was less than 2,000. By the time he became Supreme Commander in 1933, it was reported that membership had risen to 37,000. Lightner often traveled to the other 12 offices that were located throughout the United States. Here Lightner (first row, center) is seen with the Woodmen Band in Cleveland, Ohio, in 1930. (Courtesy Denver Public Library, Western History Department.)

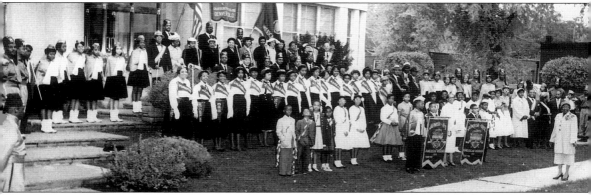

The American Woodmen Insurance Company was the largest employer of African-American office workers in Denver in the 1920s. Denver was the national headquarters for the company, which had offices throughout the United States. This photo, taken in 1952, shows men, women, and children of the American Woodmen Insurance Company standing in front of the new offices at 2100 Downing Street during their annual national convention. The young women in the second row are wearing banners representing the states where the American Woodmen had active organizations. Although the American Woodmen Insurance Company went out of business in the 1970s, the art deco style building still exists today. (Courtesy Denver Public Library, Western History Department.)

The Phillis Wheatley Colored YWCA was founded in 1916 and became an official branch of National YWCA in 1920. The building, constructed in 1920, was located at 2460 Welton Street. For almost 50 years, the branch operated a residence hall, youth camp, an employment bureau, and art and recreation classes. In 1964 it was the last traditionally black YWCA branch in United States to close its doors. This photo of members of the YWCA standing outside the building was taken in the 1930s. (Courtesy Denver Public Library, Western History Department.)

Inside the Phillis Wheatley branch of the YWCA women sit together to dine. Programs such as the Business Girls Club and the Industrial Girls Clubs helped to place over 300 women a year in jobs. Programs for younger girls such as the Girls Reserves taught etiquette and created life-long friendships among the girls. (Courtesy Denver Public Library, Western History Department.)

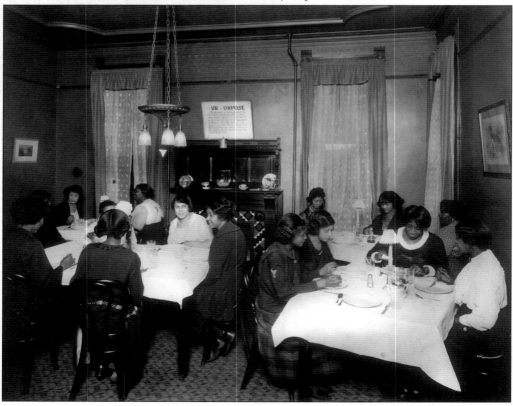

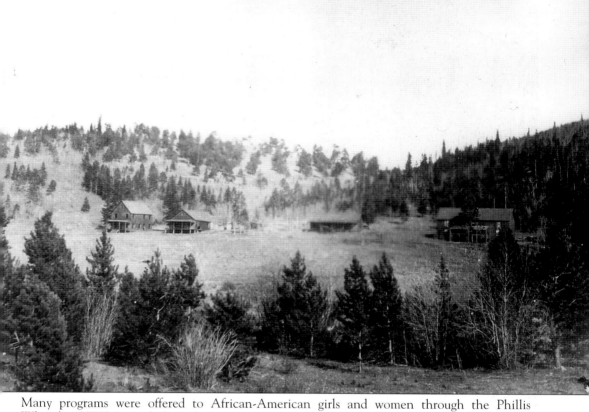

Many programs were offered to African-American girls and women through the Phillis Wheatley YWCA, including the summer mountain camp at Lincoln Hills called Camp Nizhone. This program offered African-American girls, many of which lived in Five Points, a chance to enjoy the mountains and featured events such as swimming in the river, and hiking and camping in the fresh mountain air. This photo shows the cabins that the girls stayed in, which still stands today. (Courtesy Denver Public Library, African American Research Library, Paul Stewart Collection.)

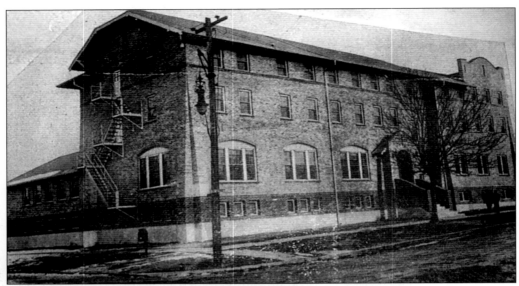

Built in 1924 at 2800 Glenarm Place, the Glenarm Branch of the YMCA was known as the "Town Hall" of Five Points because it was the focal point of social and cultural life in community. The building included a branch of the Denver Public Library, swimming pool, gymnasium, locker rooms, meeting rooms, and dormitories that were available to African Americans in the Five Points neighborhood and throughout Denver. (Courtesy Denver Public Library, African American Research Library, Paul Stewart Collection.)

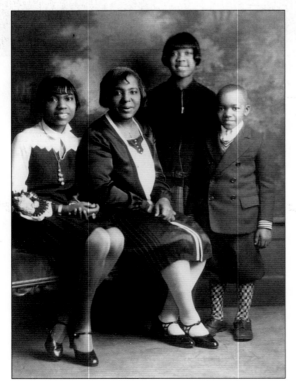

Henrietta Mosley poses for a portrait with her three children in the late 1920s. From left to right are: Charlotte, Henrietta, Thelma, and John Jr. (Courtesy Denver Public Library, African American Research Library, Mosley Family Collection.)

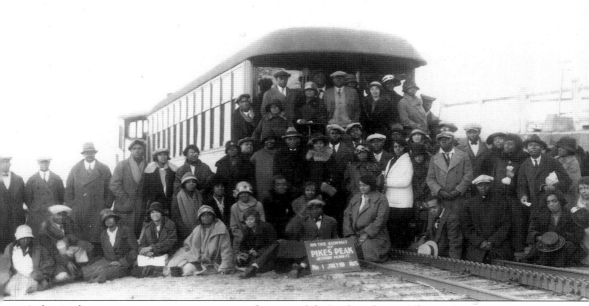

A day in the mountains was a great escape from city life. In this photo, African Americans pose on and around the Manitou and Pikes Peak cog railroad that takes tourists to the summit of Pikes Peak. Heavy coats and hats are standard on top of Pikes Peak, even on July 19, 1925 as indicated by the sign in front of the group. No doubt the temperature was brisk since Pikes Peak is one of the tallest mountains in Colorado with an elevation of 14,110 feet. The Manitou and Pikes Peak railroad has been in operation as the world's highest cog railroad since 1891 and tourists from all over the world still enjoy the ride to the top today. (Courtesy of Denver Public Library, African American Research Library, John Miller Collection.)

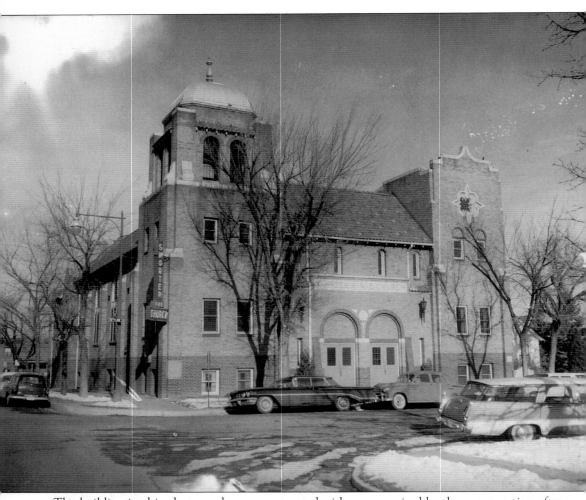

The building in this photograph was constructed with money raised by the congregation after fire destroyed the original Shorter AME Church. Constructed on the site of the original church, the building was designed in the Spanish Mission style by the Denver African-American architectural firm Ireland and Parr in 1925. Today, Shorter AME has relocated to a more modern building outside the Five Points neighborhood, and this building is being used to house the Cleo Parker Robinson Dance Ensemble, an internationally acclaimed dance studio and theater for local youth and adults. (Courtesy Denver Public Library, Western History Department, McCloud Collection.)

As pastor of Shorter AME Church, Reverend Raymond Ward helped to see the church and congregation through difficult times. After fire destroyed the church in 1925, he was the first to make a pledge in the amount of $100 to help rebuild it. This photo from 1963 shows Reverend Ward when he returned to Shorter AME as a guest speaker for the congregation. (Courtesy Denver Public Library, Western History Department, McCloud Collection.)

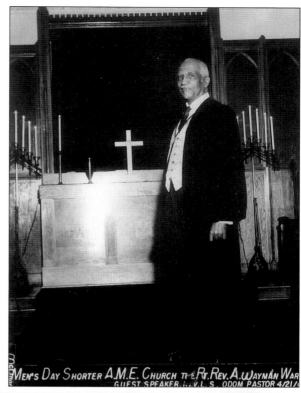

MEN's DAY SHORTER A.M.E. CHURCH THE RT. REV. A. WAYMAN WAR
GUEST SPEAKER I. V.L. S. ODOM PASTOR 4/21/

As an annual fund-raiser for the church, Shorter AME children would participate in the Tom Thumb Wedding. Under the direction of Irene McWilliams, the young actors and actresses performed a wedding complete with bridesmaids, groomsmen, floral bouquets, and of course, a cake. (Courtesy Denver Public Library, Western History Department, McCloud Collection.)

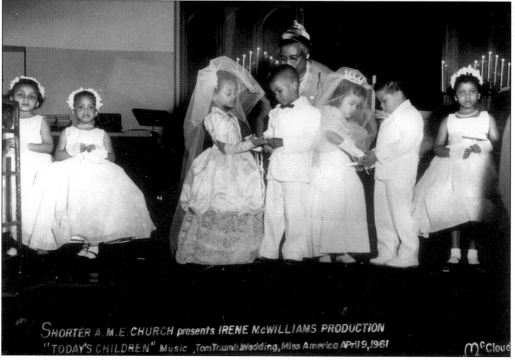

SHORTER A.M.E. CHURCH presents IRENE McWILLIAMS PRODUCTION
"TODAY'S CHILDREN" Music , TomThumb Wedding, Miss America April 9, 1961
McCloud

"Our Little Love Nest."

Located in Five Points at 2930 Glenarm Street, this two-story brick residence was the first home of Dr. Clarence Holmes and his wife Mary. Clarence Holmes titled the image on the front of the photo, "Our Little Love Nest" and then hand wrote on the back of the photo, "This is our little home. I have some beautiful flowers in the back yard—sweet peas, dalias [sic], nasturteriums [sic], and gladiolas." The photo was taken in the early 1920s and the style of the home is typical of many of the residences in the Five Points neighborhood. (Courtesy Denver Public Library, Western History Department, Holmes Collection.)

Dr. Clarence Holmes (seated on porch) poses for a picture with another man in front of the house in which his dental practice was located. The house also included a real estate agency, an employment bureau, and the mechanics labor union. (Courtesy Denver Public Library, Western History Department, Holmes Collection.)

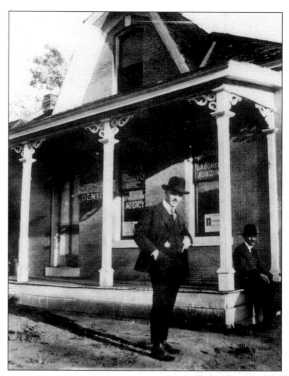

This photo was taken in 1921, not long after Dr. Holmes opened his office in Five Points, which remained in practice for 56 years. The office offered quality dental care for African Americans at a time when it was often difficult for them to find such services. Dr. Holmes was an active civic leader and was one of the founders of the Denver Branch of the NAACP. (Courtesy Denver Public Library, Western History Department, Holmes Collection.)

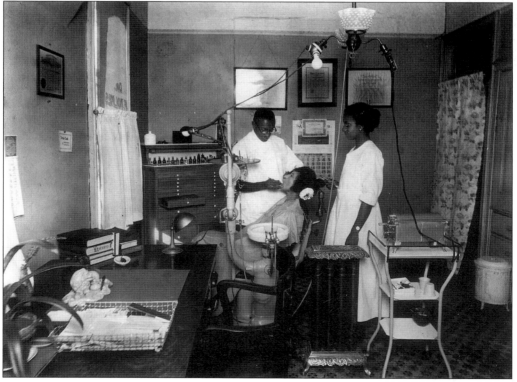

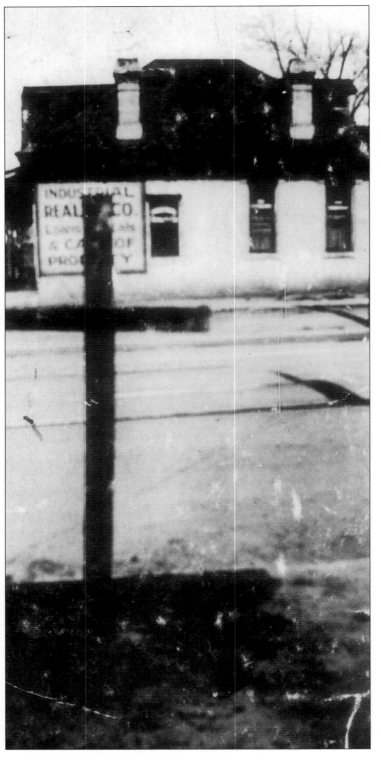

In the 1920s, Ku Klux Klan activity was at an all time high in Denver. Fifty thousand Coloradoans were in the KKK, making it second only to Indiana in greatest number of members. KKK members were elected to government, including Governor Clarence Morley, Denver's mayor Ben Stapleton, and Denver's chief of police. Communities surrounding Five Points formed "Neighborhood Improvement Associations" which created covenants that banned residents from selling their homes or property to non-whites. This photo of a burned cross in front of Dr. Clarence Holmes' dental office indicates the opposition that African Americans faced during this time in Five Points and throughout Colorado. (Courtesy Denver Public Library, Western History Department, Holmes Collection.)

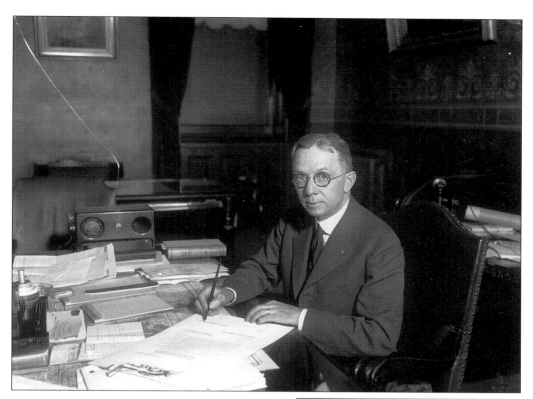

Clarence Morley was governor of Colorado from 1925 until 1927. Handwritten on the back of this portrait of him signing a document are the words in quotations "KKK Governor." (Courtesy Denver Public Library, Western History Department, Harry Rhoads Collection.)

Benjamin Stapleton was mayor of Denver from 1923 until 1931 and again from 1935 until 1947. It is believed that although he hid it well, Stapleton was a member of the KKK and pledged to help the organization heart and soul. (Courtesy Denver Public Library, Western History Department, Harry Rhoads Collection.)

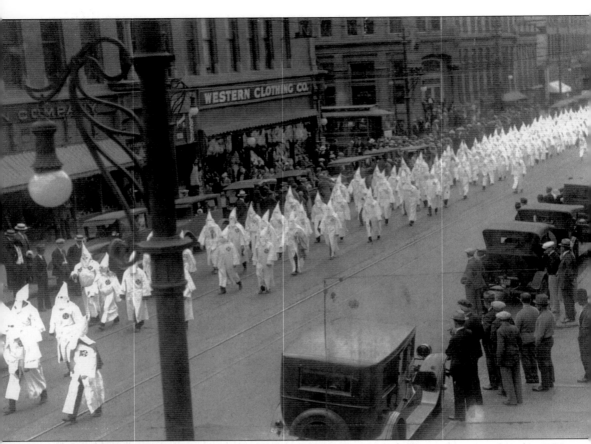

To kick off the beginning of their annual convention in 1926, hundreds of Colorado KKK members marched down Larimer Street in downtown Denver dressed in white robes and hoods. KKK rallies, picnics, and public demonstrations were common-place in Denver during this time in the city's history. Many African Americans from the Denver area can remember seeing hundreds of white hooded figures marching up to Table Mesa, just outside of Golden, where KKK members would burn a giant cross that could be seen for miles in the night sky. (Courtesy Denver Public Library, Western History Department.)

Because of the light color of his skin, Dr. Westbrook was able to infiltrate the Denver KKK in the early 1900s and alert African Americans to the group's plans. Dr. Westbrook was a physician, drug store owner, civic leader, and a delegate to the Republican National Convention that nominated Coolidge for president. (Courtesy Denver Public Library, African American Research Library.)

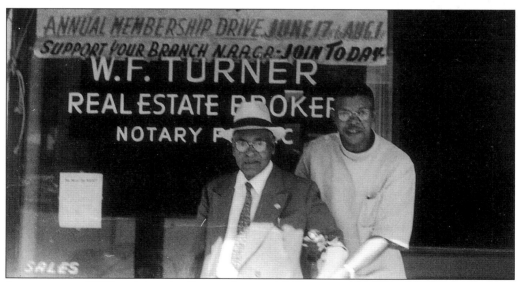

In response to KKK activity, the Denver Interracial Committee was formed in 1924, and the Denver Branch of the National Association for the Advancement of Colored People (NAACP) hosted their national convention in Denver in 1925. Here, Clarence Holmes (at left), one of the original founders of the Denver branch, poses with another man in front of the WF Turner Real Estate Office on Welton Street. The office was the headquarters of Denver Branch of the NAACP. (Courtesy Denver Public Library, Western History Department, Holmes Collection.)

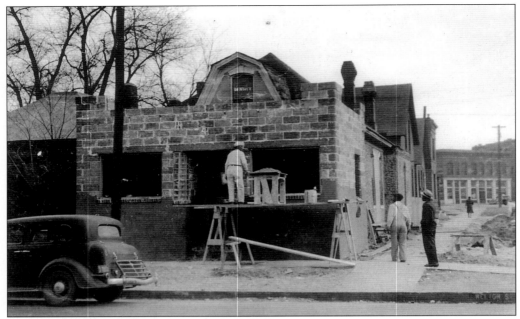

As Five Points continued to grow, African-American-owned businesses were prospering. The Welton Street business district was becoming the largest black business community in the west. The success of the business district made it possible for African-American business owners to help others in the community by providing jobs, education, and skills that might not have been available at this time. This photo shows the addition to Dr. Holmes' dental office being constructed. (Courtesy Denver Public Library, Western History Department, Holmes Collection.)

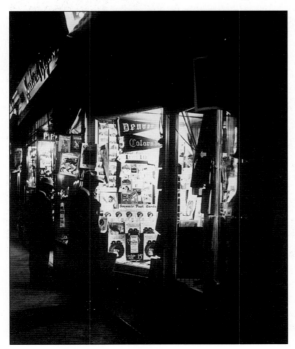

This nighttime view of a magazine and postcard store on Champa Street in Five Points shows the vitality of businesses in the area. This photo was taken in 1921, again showing that Five Points was beginning to be recognized as an important African-American business area for Denver. (Courtesy Denver Public Library, Western History Department.)

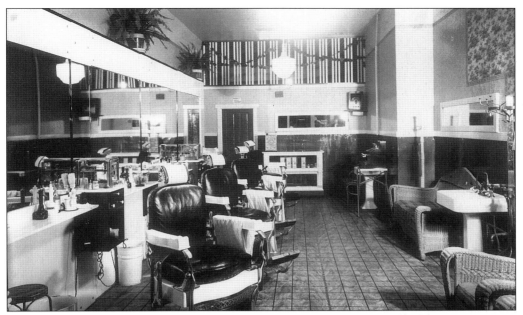

The interior of Emmet Williams Barber Shop at 2721 Welton Street had all of the appointments necessary for a first rate barber shop. The leather barber chairs, ferns, and matching sofa and chairs for guests shows the prosperity of the Welton Street business district during this time in Five Points' history. (Courtesy Denver Public Library, Western History Department.)

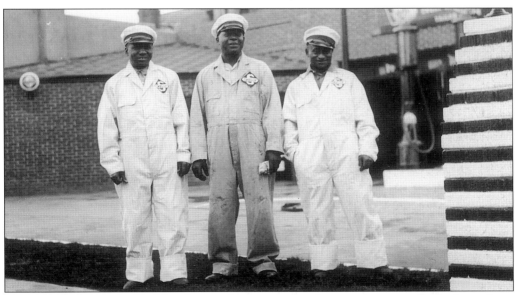

Three employees at the Da-Nite Service Station pose in their mechanics uniforms for a photo sometime in the 1930s. The service station was located at 728 East 26th Avenue and was managed by L.H. Smith. According to advertisements in the local paper, Da-Nite offered "courteous and efficient service to all" that included mechanical repairs, an electric car wash, full service filling station, and the convenience of free pick up and deliveries of cars. (Courtesy Denver Public Library, African American Research Library, Otha Rice Collection.)

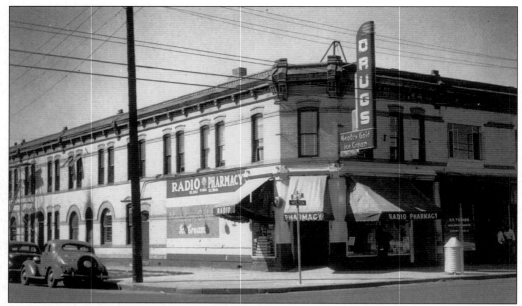

Radio Drugs was originally named Maxwell & Lawson Drug Store when Oglesvie "Sonny" Lawson and Hulett A. Maxwell opened it in 1924. In 1932 it was renamed Radio Pharmacy. Located at the corner of 26th and Welton, the pharmacy remained in the heart of the Welton Street business district until 1963. (Courtesy Denver Public Library, Western History Department, Holmes Collection.)

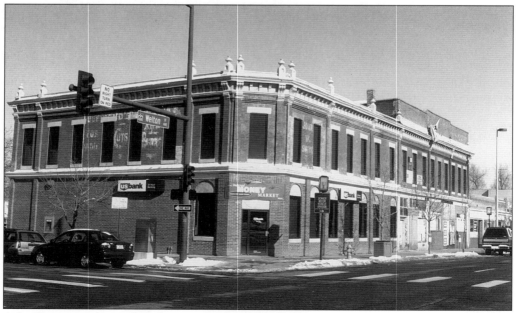

Atlas Drugs was located at the corner of 27th and Welton and was a major part of the Five Points community for many years. Many residents remember that during the time of segregation, it was the only white-owned drugstore in Denver where African Americans could receive fountain service. Today, the building is home to a branch of US Bank.

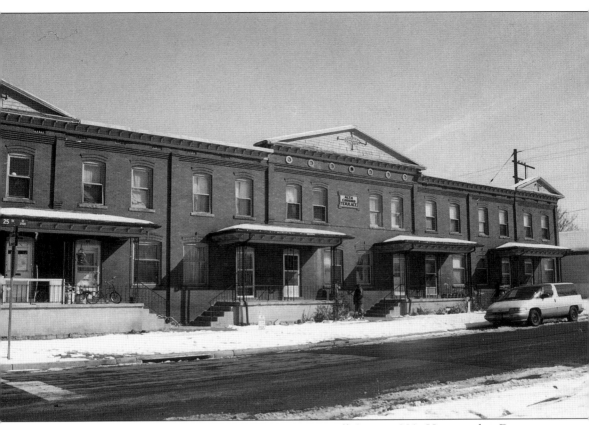

Charles Cousins Sr. was born on March 14, 1881 in Russell County, VA. He moved to Denver in 1909 with his wife Alta and their children. In Denver, he found work as a Pullman porter for the Union Pacific and Santa Fe Railroads. In his spare time, Cousins loved to watch the construction of major buildings in Denver. In 1915, using the skills he had acquired while watching construction, he built his first duplex at 2647–2649 High Street. Knowing the needs of his people in respect to such things as restrictive covenants and the difficulties of acquiring a home loan, Cousins began buying property in Five Points. Cousins would spend his days off from Pullman fixing up these buildings so he could then rent them to people in the community for a reasonable price. In 1924 and 1925 he built six terraces on the corner of Downing and East 25th Avenue (seen in this photo), which he named Alta Cousins Terrace in honor of his wife. The building is still owned by the Cousins family today.

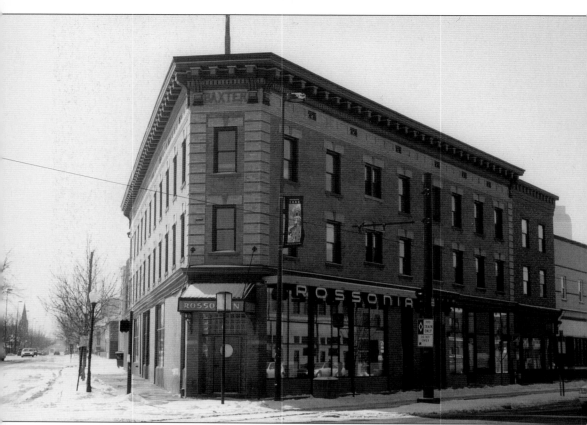

Formerly known as the Baxter Hotel, the Rossonian came into the ownership of HW Ross in 1929. The most prominent building on Welton Street, the Rossonian stands at the five-way intersection that gave Five Points its name. It quickly became Denver's premier jazz club, hosting such greats as Count Basie, Lionel Hampton, Ella Fitzgerald, and Duke Ellington as they passed through Denver on their way to Kansas City or to the West Coast. At the peak of its popularity in the 1940s the Rossonian sometimes had more white patrons than African Americans, because many blacks could not afford to pay to come in and see the shows. After many years of neglect, the Rossonian was restored in the early 1990s into an office building featuring an art gallery on the first floor.

Born in Denver in 1890, Paul Whiteman was a controversial figure among jazz musicians because he was dubbed the "King of Jazz." He earned this name because he was the most popular jazz act in America during the 1920s. Seeking to "make a lady out of jazz," Whiteman's orchestra featured skilled musicians who offered versatile shows that included waltzes, pop-tunes, jazz, and classical works. Originally a classically trained violinist, George Morrison's father studied under Whiteman. (Courtesy Denver Public Library, African American Research Library, Paul Stewart Collection.)

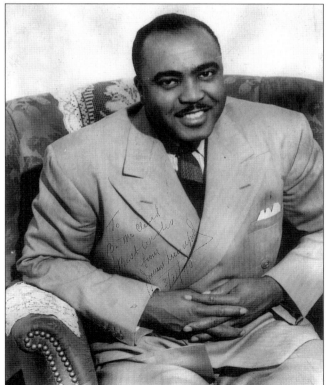

The legendary Jimmy Lunceford played for a short time with George Morrison's orchestra at the beginning of his career. Although Lunceford was a trained musician, he was better known as a bandleader. Lunceford's orchestra was recognized not only for its music, but also for the visual show that went along with the act. This portrait of Lunceford, autographed to Burnis McCloud, was probably given to McCloud when Lunceford came to Denver to perform. (Courtesy Denver Public Library, Western History Department, McCloud Collection.)

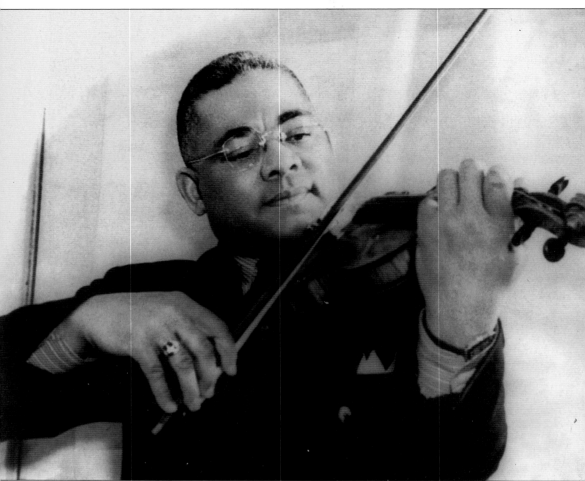

Following in the footsteps of his father who was known as the "Champion Fiddler of Missouri," George Morrison aspired to be a concert violinist. Because of racial prejudices of the time, Morrison was unable to become a concert violinist and turned to jazz and big band to show his musical talent. Morrison and his orchestra enjoyed much success as Vaudeville headliners, as well as traveling and performing throughout the United States. By the 1920s, Morrison and his 12-piece orchestra were quite well known, and even traveled to England to perform for the king and queen. Although his music was recognized throughout the United States and abroad, Morrison always called Denver home. He was the violinist for Shorter AME Church for 58 years, and devoted much of his time giving violin lessons to children in the neighborhood and performing at local schools. (Courtesy Denver Public Library, African American Research Library, Marian Morrison Robinson Collection.)

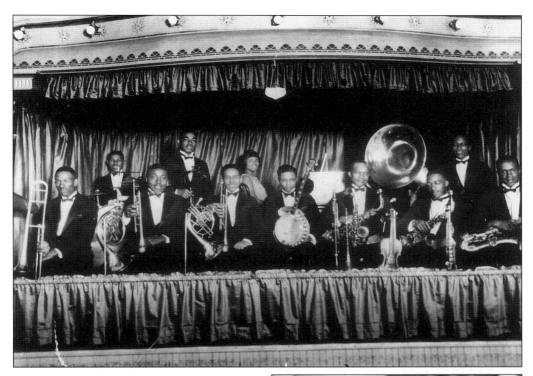

The George Morrison Orchestra from left to right are: unidentified, unidentified, Sam Franklin, George Morrison, Joe Miller, Desdemona Davis, Charley Lewis, Andy Kirk (future bandleader), Cuthbert Byrd, unidentified, and unidentified. (Courtesy Denver Public Library, Western History Department, McCloud Collection.)

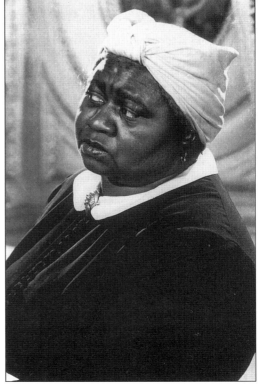

Hattie McDaniels was born in Wichita, Kansas on June 10, 1895. She came to Denver in 1915 to make her show business debut singing with George Morrison's Orchestra. Although she enjoyed a successful career as a jazz and blues singer, she is most famous for her role as "Mammy" in *Gone with the Wind*. In 1939 she was the first African American to win an Academy Award for Best Supporting Actress for her portrayal of the character. (Courtesy Denver Public Library, Western History Department.)

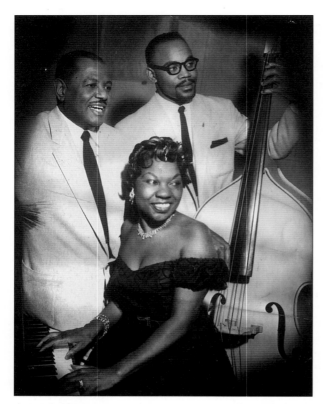

When musicians came to Five Points to play, Charlotte Cowans was always there to accompany them on the piano. She was taught the tricks of the trade from the great jazz pianist Art Tatum, and remembers playing with other greats such as Duke Ellington and Count Basie. Cowans continues to play piano in the community and is a member of Shorter AME church. (Courtesy Denver Public Library, Western History Department, McCloud Collection.)

The Casino was opened by George Morrison in the 1920s and was the one of the best places to see jazz performed. Because many musicians were not allowed to stay at hotels in Denver, many Five Points residents opened their homes to them. George Morrison often had guests such as Duke Ellington in his home, and they would always repay the favor by playing at his club. The Casino continues its musical tradition today, featuring many types of local bands.

Called the "Mayor of Five Points," Benny Hooper owned the Ex-Service Men's Club at 2626 Welton Street. After returning to Denver after World War I, African-American soldiers found that they were still being discriminated against in places such as restaurants, clubs, and hotels. Because of this, Benny Hooper decided to open his own club, which included a ballroom, pool hall, recreation center, and hotel. Hooper was also known for his charitable activities. During the Depression years, Hooper distributed food to the needy by making stew from rabbits that were donated by local sportsmen. (Courtesy Denver Public Library, African American Research Library, Paul Stewart Collection.)

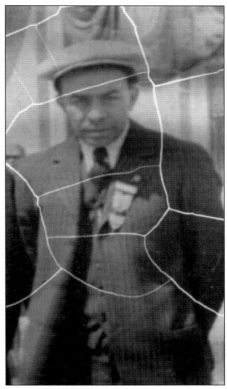

The Ritz Café was located at the corner of 26th Street and Welton Street. Five Points residents would go to the Ritz Café on Sunday morning to enjoy "grits at the Ritz" before church. In this photo from sometime in the 1930s, three waitresses and the bartender pose for the camera. A poster on the wall lists members of the Denver Colored Chamber of Commerce. (Courtesy Denver Public Library, African American Research Library, Paul Stewart Collection.)

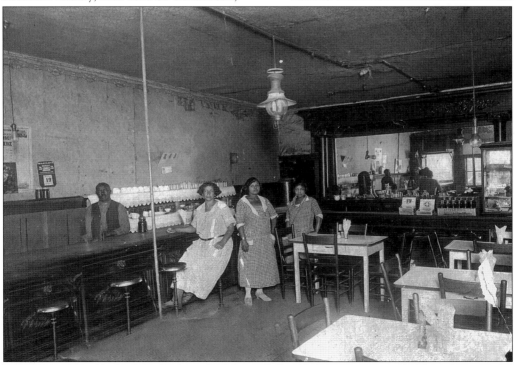

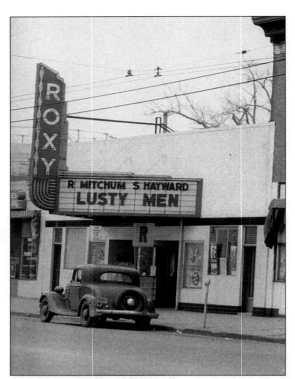

The Roxy Theater was the only African-American movie house in Denver at the time it was opened by Abel Davis on Welton Street in 1934. During the Depression the price to see a movie was five cents. However, the Roxy only showed half of the movie at a time, ensuring that patrons would come back to see the end of the movie the next week. (Courtesy Denver Public Library, Western History Department, McCloud Collection.)

Leslie Smith (standing, center) and other members of the Gala-Da Club pose for a photo in November of 1935. The Gala-Da's were among many of the social organizations and fraternal clubs that were an integral part of African-American community life in Five Points. (Courtesy Denver Public Library, African American Research Library, Otha Rice Collection.)

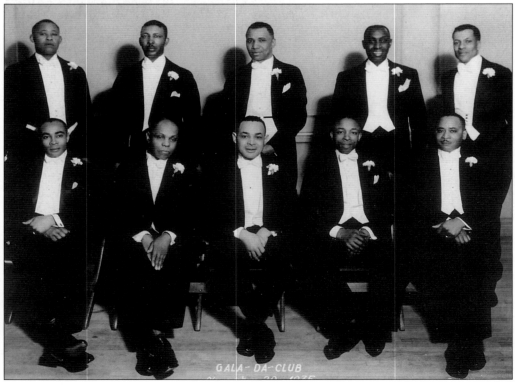

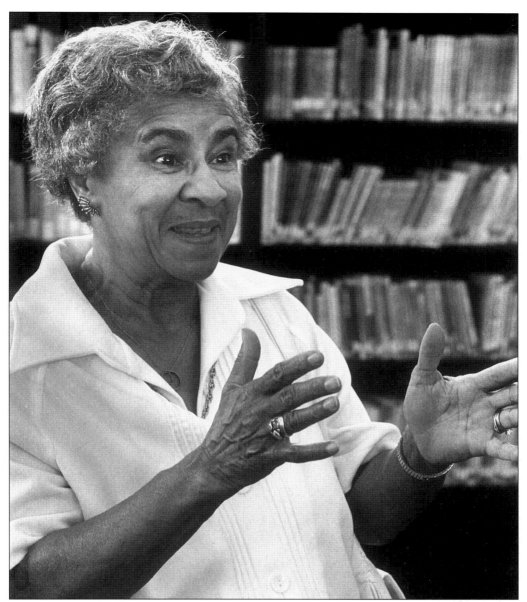

When Marie Anderson Greenwood took a job teaching first grade at Whittier Elementary in 1938, she broke the racial barrier for generations of African-American teachers to come. Greenwood was the first African American to teach in the Denver Public School System. Hired under a three-year probation, Greenwood carried an enormous amount of responsibility because the school system said that they would not hire any more blacks until she passed her probationary period. Of course, Greenwood passed her probationary period and kept the door open for other African Americans. Greenwood continues to be very active in the community today. She volunteers her time by reading to classes, teaching children to read one-on-one through the Denver Public Library, and sings in the choir at Shorter AME. In this photo, Ms. Greenwood's expressive manner in which she reads to children is evident. (Courtesy Denver Public Library, Volunteer Services Department.)

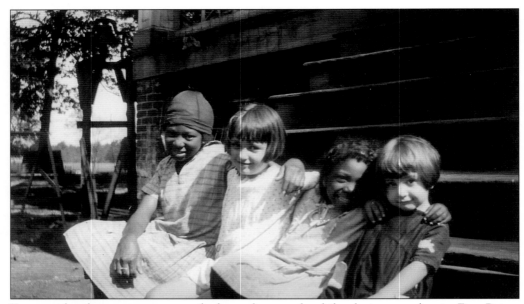

Young girls take a moment to smile for a photograph while playing together in Five Points sometime in the 1930s. (Courtesy Denver Public Library, Western History Department, Harry Rhoads Collection.)

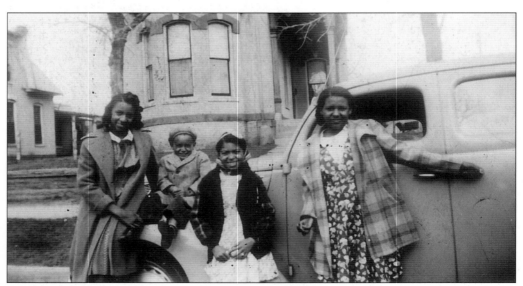

Neighborhood kids pose for the camera near a car parked at 2428 Clarkson Street in Five Points in 1938. (Courtesy Denver Public Library, Western History Department, Holmes Collection.)

Five

PROSPERITY
(1940–1950)
POST WORLD WAR II IN FIVE POINTS

Located at 22nd Street and Larimer Street, the Burlington Hotel was built in 1891. Because of its proximity to the railroads, its largest clientele at this time was railroad workers. However, it played a more interesting role in the 1940s. In the early 1940s Governor Carr welcomed Japanese Americans to Denver despite the antipathy towards them because of the 1941 bombing of Pearl Harbor. Japanese Americans began moving into Five Points between 21st and 23rd Streets and the Burlington Hotel was often the place where newcomers sought lodging. (Courtesy Denver Public Library, Western History Department.)

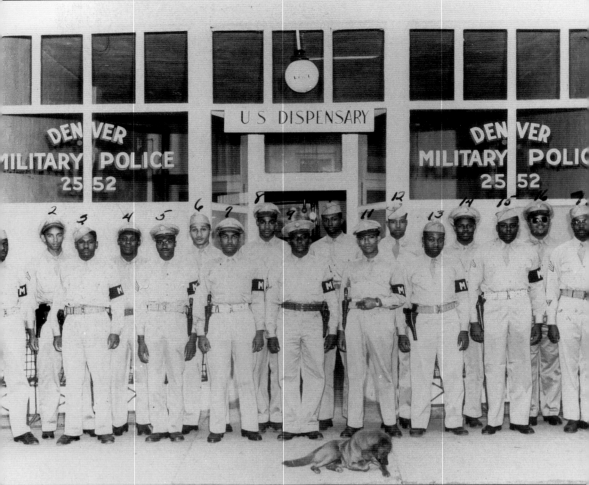

This African American Military Police unit patrolled the Five Points neighborhood from 1946 to 1950. The soldiers were allowed to only arrest other African American soldiers. If there was a problem with a white soldier, a white military policeman had to be called to make the arrest. The dog in the photo, named Tiger, belonged to Sergeant Martin (number 9 in the photo); however, the soldiers nicknamed him "Snitch." He earned this nickname by patrolling the alleys and streets for drunks. When he found someone who had too much to drink, he would return to the station and whine until one of the men followed him to the spot where the person had fallen down. In this photo, the MP's pose in front of the police station located at 2552 Welton Street. (Courtesy Denver Public Library, African American Research Library, Delores Dillworth Collection.)

Bernard Gipson began his medical career at Howard University. There he studied under Dr. Charles Drew, who discovered the process of preserving blood plasma during World War II. Dr. Gipson came to Denver in 1954 to serve as chief of surgery at Lowry Air Force Base, becoming the first African American board-certified surgeon in Colorado. He was also a clinical associate professor of surgery at the University of Colorado Health Sciences Center. Gipson has received numerous awards for volunteering his medical services to the community. (Courtesy Denver Public Library, African American Research Library, Bernard Gipson Collection.)

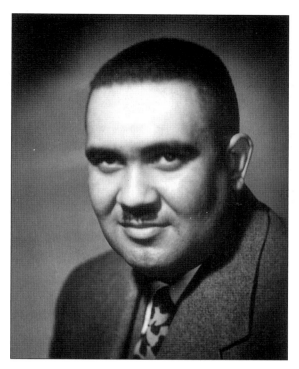

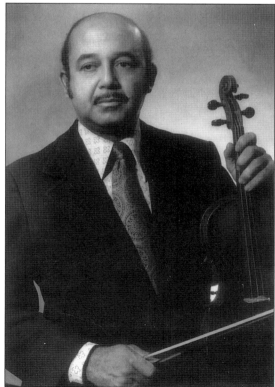

At the age of seven Jack Bradley moved from Illinois to Denver with his family. While attending Manual High School from 1932-1936 he became a charter member of the Denver Civic Symphony. After graduating from the University of Denver, Jack Bradley played viola with Denver Symphony Orchestra from 1940-41, becoming the first African American member of the orchestra. After serving in World War II, Bradley returned to the symphony from 1946-1949. Bradley was also chairman of the Music Department at Texas Southern University. (Courtesy Denver Public Library, Western History Department.)

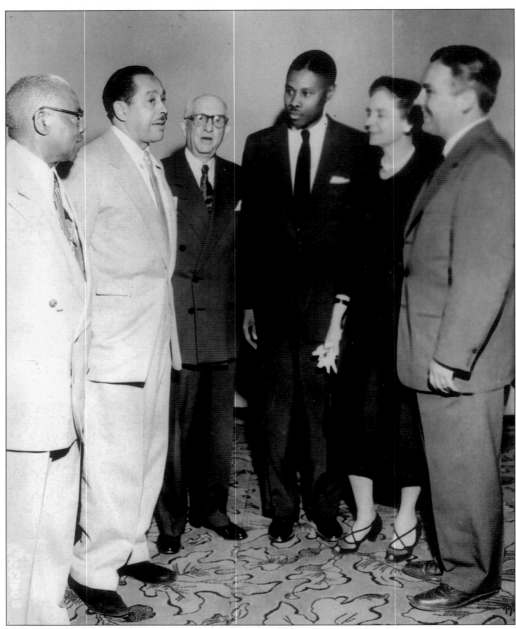

Elected as mayor of Denver in 1947, Quigg Newton helped to establish non-discrimination laws for Denver. He set in place laws that prohibited segregation in public swimming pools, as a well as a policy of non-discrimination in recreational facilities, city government jobs, and city services. Quigg Newton also established the Mayor's Committee on Human Relations. Here he is seen meeting with singer and bandleader Cab Calloway. From left to right are: George Morrison (local musician), Cab Calloway, Ray Perkins (local radio personality), Sebastian Owens (Executive Director of the Colorado Urban League), Virginia Newton (First Lady of Colorado), and Quigg Newton. (Courtesy Denver Public Library, Western History Department, McCloud Collection.)

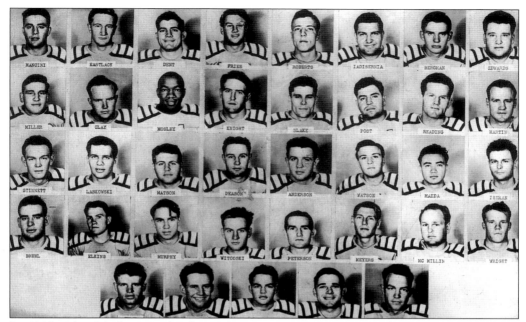

In 1943, John Mosley was the first African American to play football for Colorado State University. In recognition of his athletic efforts as the right guard for the team, Mosley received the "All-American" and "Most Valuable Player" trophy during his senior year. Mosley was also an accomplished athlete with the CSU Wrestling Team. (Courtesy Denver Public Library, African American Research Library, Mosley Family Collection.)

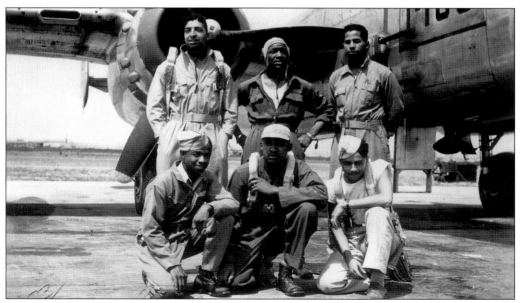

The 32nd Fighter Group poses for a photo at the Tuskegee Army Air Field in Alabama on July 18, 1945. Standing from left to right are: Hubert Jones, John Moseley, and George O'Martin. Kneeling from left to right are: Mitchell Green, John Bruner, and Keith Stanigan. (Courtesy Denver Public Library, African American Research Library, Mosley Family Collection.)

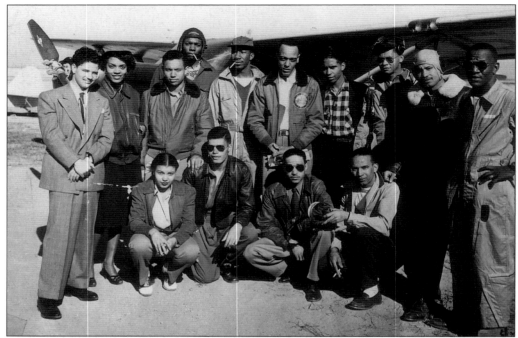

The Glenarm Branch of the YMCA offered many recreational programs for local children and young adults. In this photo from the 1950s, John Mosley (far right) stands with the "Swoops Club" of the YMCA. A former Tuskegee Airman, Mosley taught young people from the Five Points community how to fly and maintain airplanes through lessons that included frequent cross-country training flights. (Courtesy Denver Public Library, African American Research Library, Mosley Family Collection.)

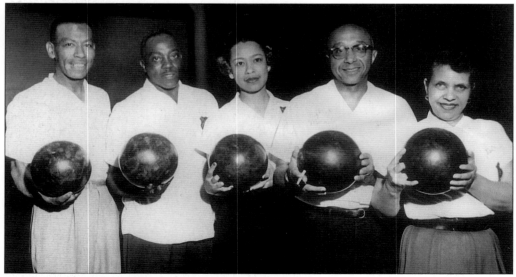

Members of the 1959 Glenarm YMCA Bowling League pose for a photo. The members are from left to right: unidentified, ? Hood, unidentified, James Flanigan, Dolly Tinsley. (Courtesy Denver Public Library, Western History Department, McCloud Collection.)

The Central States Golf Tournament was an annual event that was sponsored by the Glenarm YMCA. Here participants from all over the western region enjoy a day of golf at the 21st Annual Tournament in 1954. (Courtesy Denver Public Library, Western History Department, McCloud Collection.)

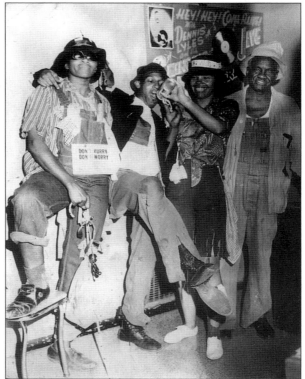

The annual Membership Drive and Victory Dinner for the Glenarm Branch of the YMCA helped to raise funds for the organization. Performances by the members were always included in the schedule and were often comedy sketches that made fun of the old minstrel shows. On the back of this print is written "hobos." (Courtesy Denver Public Library, African American Research Library, Otha Rice Collection.)

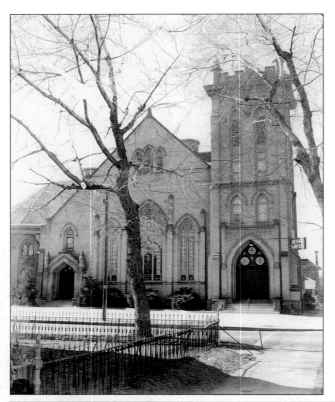

In 1949, the New Hope Baptist Church purchased this building at East 23rd Avenue and Ogden Street. Originally constructed in 1906 by the 23rd Avenue Presbyterian Church, the gothic revival style church features blonde brick construction, a three-story tower, and a beautiful stained glass window. The New Hope Baptist Church was established in 1922. (Courtesy Denver Public Library, Western History Department, McCloud Collection.)

All eyes are directed to the choir director as the New Hope Baptist Church Choir waits for their cue to begin singing. (Courtesy Denver Public Library, Western History Department.)

Members of the Skyway Attendant Service Company pose in uniform for a photo at Stapleton Field on May 29, 1951. Albert Pinkard (far right) was the Chief Service Director for the group that worked as baggage handlers at Stapleton Airport. At the time, many African Americans considered this a good job because it was well paying and had a good benefits package for the workers and their families. (Courtesy Denver Public Library, African American Research Library, Otha Rice Collection.)

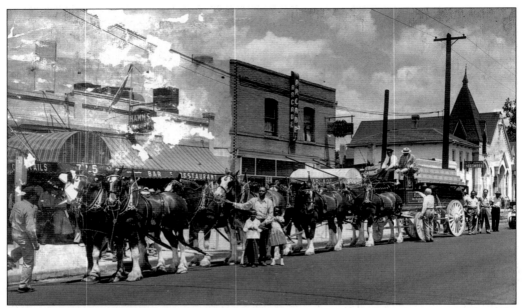

When the Budweiser Wagon Clydesdales drove into Five Points pulling the wagon, it brought everyone out to see them. Standing with the team of horses are Otha Rice and his two children as well as other Five Points citizens. (Courtesy Denver Public Library, African American Research Library, Otha Rice Collection.)

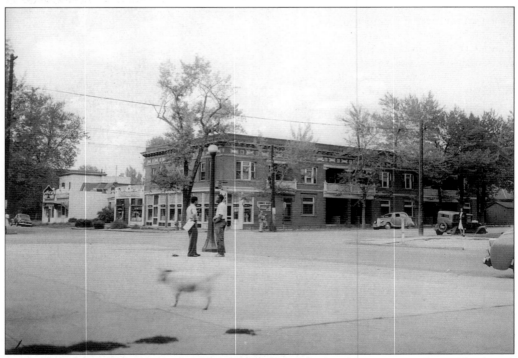

Two men stop to talk at a corner in the Five Points neighborhood sometime in the 1930s. Across the street is Johnnies Buffet. (Courtesy Denver Public Library, Western History Department.)

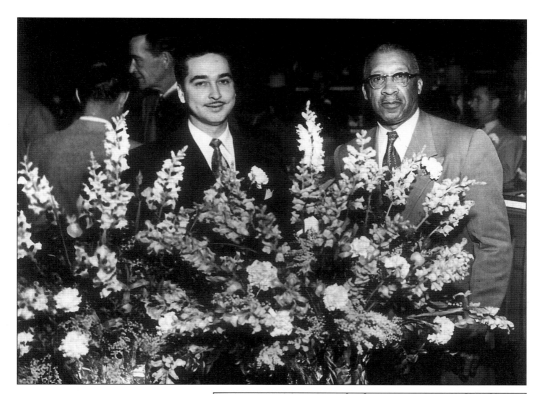

Elvin Caldwell was a member of the Colorado State Legislature from 1950–1955, and was the first African American to be elected to Denver's City Council in 1955. He served three of his five terms as council president. He is seen here (above, at left) standing with Earl Mann. (Courtesy Denver Public Library, African American Research Library, Earl Mann Collection.)

The Equity Savings and Loan Association was founded by Elvin Caldwell in 1957 and was located on Welton Street on the corner of 25th Street. At the time the business started, it was the only all African-American financial institution in Colorado. (Courtesy Denver Public Library, Western History Department, McCloud Collection.)

McKinnley Harris bought Public Real Estate in the 1940s. At this time restrictive covenants, racism, and segregation made buying a home a difficult venture for African Americans. Public Realty served the African-American community of Five Points and the surrounding areas by offering loans and an employment service in addition to the real estate services. Still located in the original offices at 2608 Welton Street, McKinnley Harris' sons, Patrick and Verne, have taken over the family business. (Courtesy Denver Public Library, Western History Department, Holmes Collection.)

The Petal Shop has been an important part of the business district in Five Points for many years and continues to be today. Located at 2602 Welton Street, Tommie Dotson is the current owner of the shop that still specializes in floral arrangements, cards, and gifts. This photo of the interior of the shop was taken in the 1950s. (Courtesy Denver Public Library, Western History Department, McCloud Collection.)

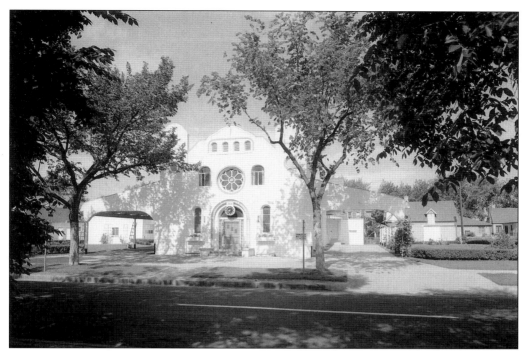

Granberry Mortuary was one of the principle funeral homes for the Five Points area and the African American community in Denver for many years. Located at 25th Street and Ogden Street, Granberry was one of the original African American owned mortuaries in Denver. Today, Pipkin Mortuary occupies the mission style building, continuing the tradition of serving the Five Points community. (Courtesy Denver Public Library, Western History Department, McCloud Collection.)

Reverend David Mallard was one of numerous Five Points entrepreneurs. Mallard's Grocery & Confectionery was located at 22nd Street and Downing Street for many years. Seen here with his wife and nephew, Rev. Mallard was a dedicated follower of "Father Divine," as evidenced by the posters in the shop windows. (Courtesy Denver Public Library, African American Research Library, Paul Stewart Collection.)

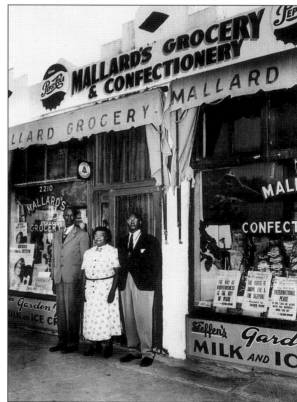

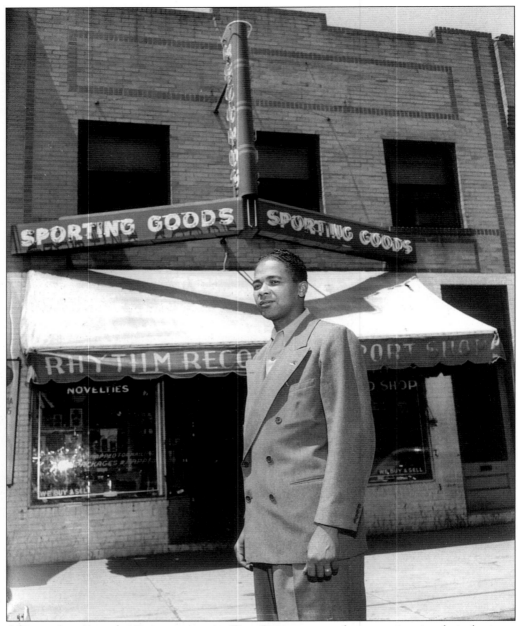

African American business owners in Five Points were often creative in their business strategies. In this photo, Leroy Smith poses proudly in front of his business, Rhythm Records and Sports Shop. Located along Welton Street in the business district, the shop stocked all the latest hits of the time, as well as sporting goods and novelties. Mr. Smith was also Denver's first African American disc jockey, and owner of The Voters Club. (Courtesy Denver Public Library, Western History Department, McCloud Collection.)

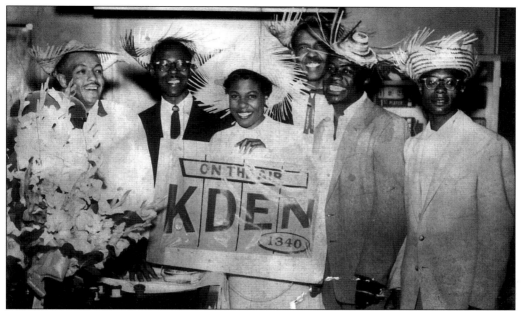

KDEN was Denver's first radio station to broadcast jazz music. Started in 1957 by owner Ed Koepke and radio personality Gene Amole, the station featured mostly classical music, with a combination of news and educational programming. Five Points residents tuned in to 1340 on the AM dial to listen to "The Art of Jazz" at 5:00 pm on weekdays. In 1973, KDEN switched to an all-news format. (Courtesy Denver Public Library, African American Research Library, Otha Rice Collection.)

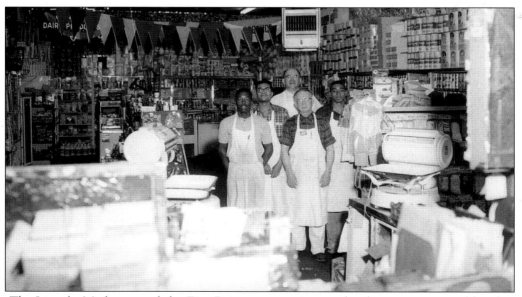

The Lincoln Market served the Five Points community as a local grocery store and butcher shop. This interior photo shows that the market was completely stocked with any supply that the community could need. (Courtesy Denver Public Library, Western History Department, McCloud Collection.)

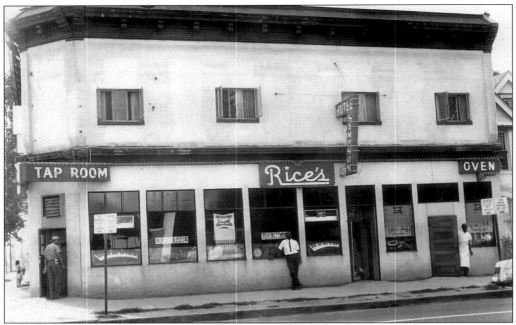

Otha Rice stands outside his business, which was located at the corner of 28th Street and Welton Street in Five Points. The building included a jazz and blues club, a bar, and a restaurant on the first floor and the Simmons Hotel on the second floor. Otha Rice was a native of Texas and is remembered for helping to bring the traditional African American celebration of Juneteenth to Denver in 1953. (Courtesy Denver Public Library, African American Research Library, Otha Rice Collection.)

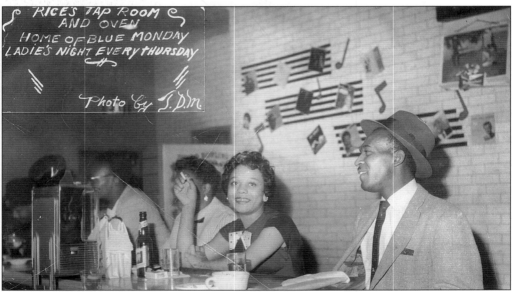

Patron's enjoy the atmosphere inside Otha Rice's Tap Room and Oven. The club featured live jazz and blues every week on "Blue Monday" and every Thursday was "Ladies Night." (Courtesy Denver Public Library, African American Research Library, Otha Rice Collection.)

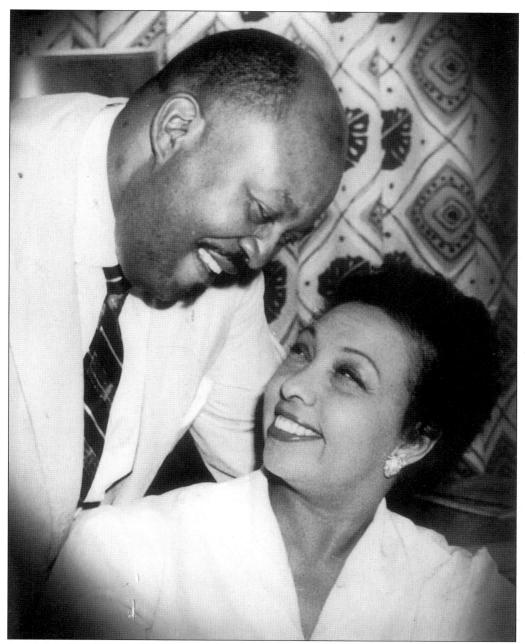

Burnis McCloud was a photographer that documented the life of Denver African Americans from World War II well into the 1970s. He photographed everything from architecture and everyday life to social events and weddings. He was the principle choice among African Americans for recording important social and political events in the community. He was always present when influential people such as Martin Luther King Jr. or other political figures came to town. He also photographed famous entertainers that came to Five Points. Here he is seen with Josephine Baker. (Courtesy Denver Public Library, Western History Department, McCloud Collection.)

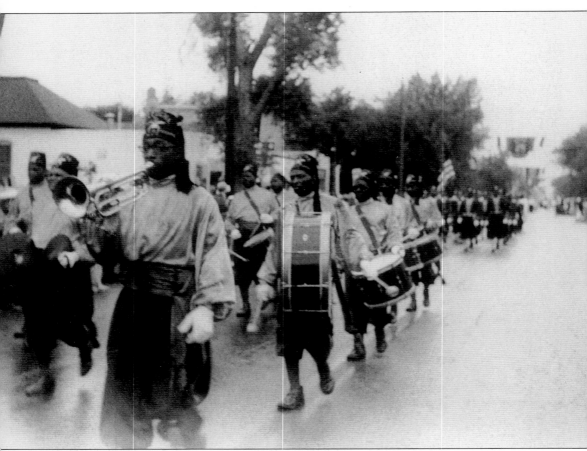

In 1953, the Ancient Egyptian Arabic Order, Nobles of the Mystic Shrine, commonly known as the Shriners, held their National Convention in Denver. To start off the convention, Shriners from all over the country marched in a parade that began at City Hall, traveled to 16th Street, proceeded down Welton Street, through the Five Points neighborhood, and finally commencing at Downing Street. Here, members of the Shriners Band march in uniform for the parade. (Courtesy Denver Public Library, Western History Department, Holmes Collection.)

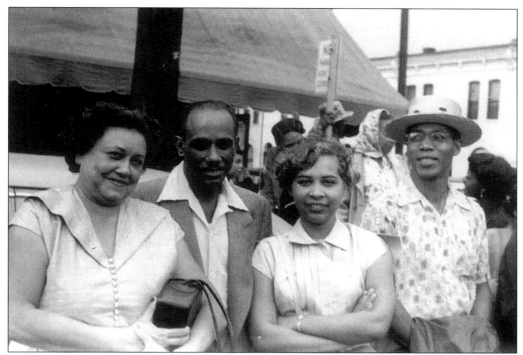

Five Points residents pose for a photo while waiting for the Shriners Parade to pass by on Welton Street. (Courtesy Denver Public Library, Western History Department, Holmes Collection.)

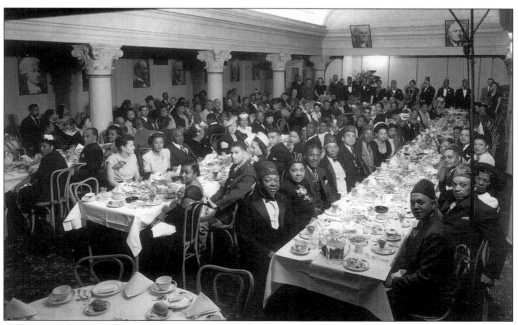

A Denver chapter of Shriners gather together for a formal dinner that was part of their annual convention. (Courtesy Denver Public Library, African American Research Library, Otha Rice Collection.)

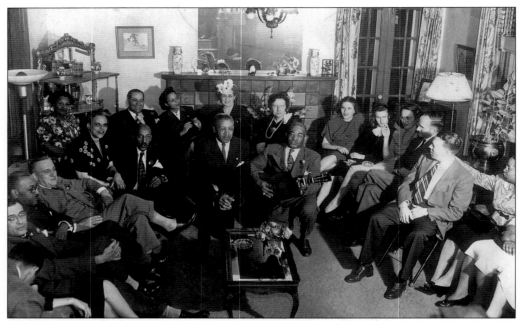

In addition to being a Colorado State Representative, Earl Mann was also very active in the community. He was a member of the American Legion, VFW, Disabled Veterans, Glenarm YMCA, and Shorter AME Church. Here he is seen (kneeling on left) with George Morrison (holding guitar) and Dr. Clarence Holmes (sixth from left) at a party at his home sometime in the 1950s. (Courtesy Denver Public Library, African American Research Library, Earl Mann Collection.)

Social Clubs continued to be a part of African-American community life in post World War II Five Points. Both men and women formed numerous social and fraternal groups that brought community members together not only to socialize, but also to help the community with charitable causes. Here the Owl Club poses for a photo during the Tenth Annual Debutante Ball in 1961. (Courtesy Denver Public Library, Western History Department, McCloud Collection.)

The Owl Club was the first African-American men's club to host a debutant ball for young black women in Denver. Unlike traditional debutantes that were chosen on the grounds of social status and beauty, Owl Club Debs were expected to be academically successful and active in the community, as well as graceful and beautiful. In this photo, debutantes are presented to the Owl Club at the 1956 Valentine's Day Dancing and Presentation of Debutantes Party. (Courtesy Denver Public Library, Western History Department, McCloud Collection.)

Owl Club Debutantes gather together with their mothers and friends for a debutante tea. (Courtesy Denver Public Library, African American Research Library, Otha Rice Collection.)

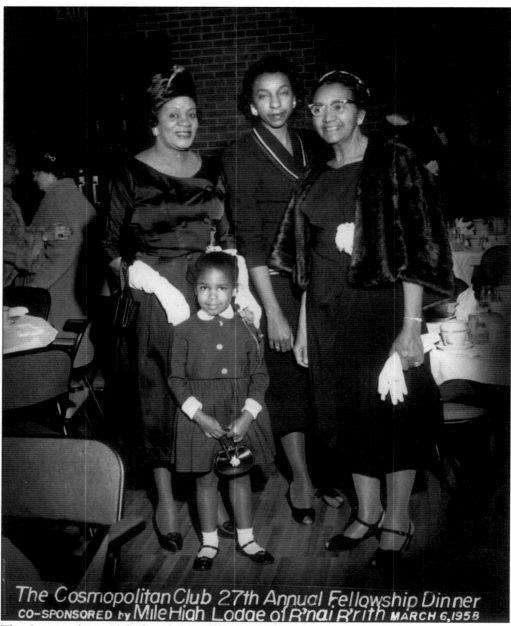

The Cosmopolitan Club 27th Annual Fellowship Dinner
CO-SPONSORED by Mile High Lodge of B'nai B'rith MARCH 6,1958

The Cosmopolitan Club, founded by Clarence Holmes and Jack Boyd in 1931, was created in reaction to the racial segregation that African Americans faced during the 1920s and 1930s in Denver. The motto of the club was "Humanity Above Race, Nationality, or Creed" and the membership included people from many different backgrounds and ethnicities that fought for racial equality by protesting segregation of public places such as restaurants and theaters. As the group's membership grew, the group continued to defend equal right issues such as equal educational opportunities and fair housing issues. This photo is from the 27th Annual Fellowship Dinner in 1958. (Courtesy Denver Public Library, African American Research Library, Otha Rice Collection.)

Young African-American men pose for a photo in front of Manual High School in 1953. (Courtesy Denver Public Library, Western History Department, Holmes Collection.)

Manual High School girls pose for a photo and wait for the boys to ask them to dance. "April in Paradise" was the theme of the 1959 Senior Prom at Manual High School. (Courtesy Denver Public Library, Western History Department, McCloud Collection.)

The Cousins family was known throughout the community for their annual Christmas displays at their homes. Here Sarah Sims (Charles Cousins' sister) stands in front of her home singing carols. The year was 1957, as indicated by the giant birthday cake that is dedicated to "our savior's birthday." (Courtesy Denver Public Library, Western History Department, McCloud Collection.)

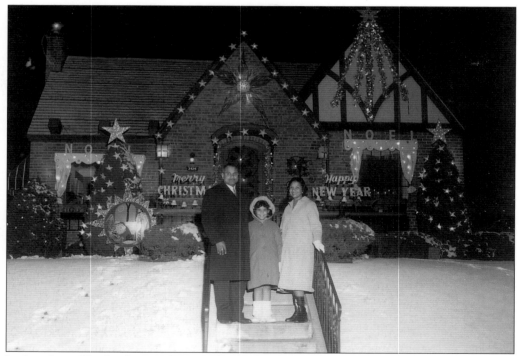

In this photo Charles Cousins Jr. poses for the family Christmas card with his wife and daughter in front of their decorated home in 1963. (Courtesy Denver Public Library, Western History Department, McCloud Collection.)

Six

CHANGE
(1960–1980)
FIVE POINTS FACES
THE CHALLENGES OF THE DAY

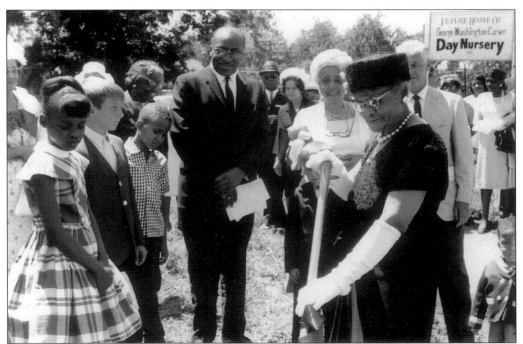

In 1966, the George Washington Carver Nursery moved to larger, more modern facilities in the City Park West neighborhood at 2260 Humbolt Street. This photo shows the dedication ceremony and ground breaking that welcomed the new facility to the area. (Courtesy Denver Public Library, Western History Department, Holmes Collection.)

This photo of Mrs. Wheeler's Barber's Shop captures a moment of life in Five Points during the 1960s. A sign on the wall states that ladies haircuts were only $2.00 and a shave was $1.50. (Courtesy Denver Public Library, Western History Department, McCloud Collection.)

Demolition was a common site in the Five Points neighborhood in the 1960s and 70s. Old houses, apartment buildings, and commercial structures were torn down to make way for Urban Housing Projects and parking lots. The sign that the man is standing beside in this photo reads, "This house will be down in ___ days. McRea Demolition." (Courtesy Denver Public Library, Western History Department, McCloud Collection.)

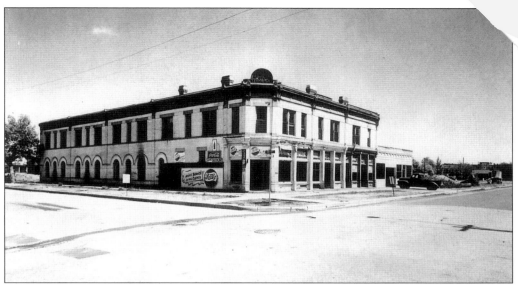

This photo of the building at 27th and Arapahoe was taken in 1939. It contained a market on the ground level with housing above. In the 1950s the building was torn down during the postwar "Slum Clearance" activities of the Denver Housing Authority. This site would become the new home for the Arapahoe Courts public housing complex. (Courtesy Denver Public Library, Western History Department.)

Almost the entire area between Arapahoe and Lawrence Streets from 25th to 34th Streets was cleared to develop Curtis Park Homes and Arapahoe Courts. Ironically most of the housing complexes, which were declared "well arranged" and "carefully considered" by the Denver Housing Authority, have been torn down to make way for the city's $34 million Hope 6 Project. The project will include 286 mixed-income townhouses and apartments. This photo shows the Arapahoe Court today, which will eventually be torn down to make way for the Hope 6 Project.

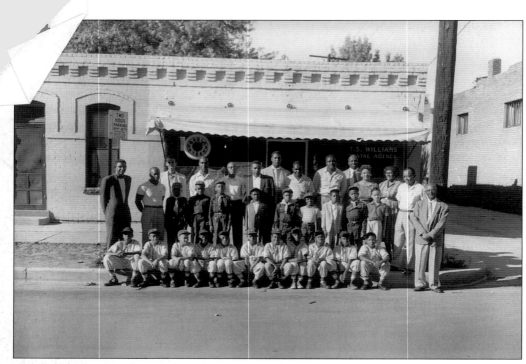

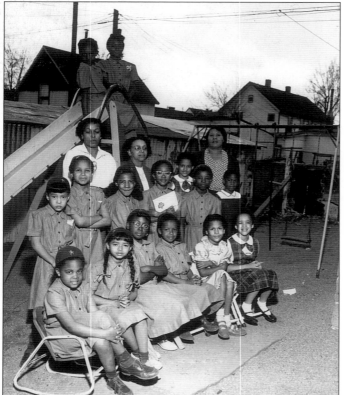

The boy scouts baseball team from the Five Points area poses for a group portrait with the troop leaders, coaches, fathers, and mothers outside of W.F. Turner's Real Estate Agency along Welton Street sometime in the 1960s. Some of the children are wearing their boy scouts uniforms while others wear their baseball uniforms. (Courtesy Denver Public Library, Western History Department, McCloud Collection.)

Brownies and their troop leaders pose for a photo on and around playground equipment in the backyard of a home in Five Points sometime in the 1960s. (Courtesy Denver Public Library, Western History Department, McCloud Collection.)

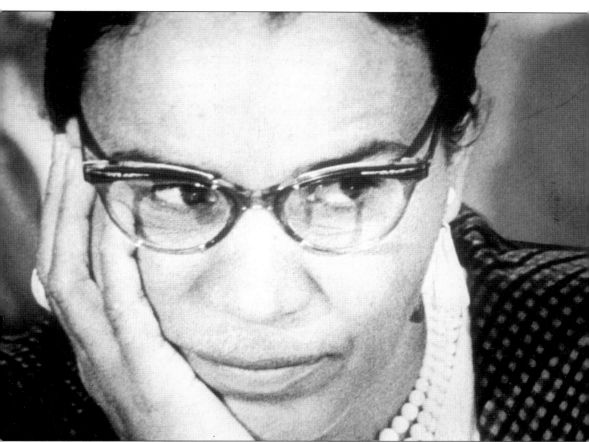

When Rachel Noel was elected to the Denver School Board in 1965, she was not only the first African American to be elected to the school board, she was also the first African American to be elected to a city-wide office. However, she is most recognized as the person that ultimately was responsible for the desegregation of the Denver Public School system. In 1968, Noel authored a school board resolution that was upheld by the Colorado Supreme Court and City of Denver as a model for the entire country and created equal educational opportunities for all students. (Courtesy Paul Stewart Collection.)

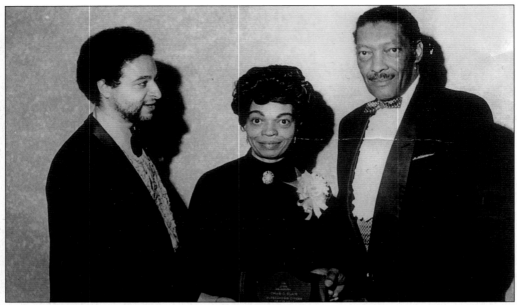

Omar Blair was the first African American to be elected president of the Denver Public School Board. He served on the school board for 12 years and was also responsible for helping to open a career education center for Denver residents. He is also a member of Shorter AME Church. In this photo, Blair (far right) is excepting an award for citizen of the year in 1976. Joining him are Phillip Jones (Denver attorney) and his wife Jeweldine. (Courtesy Denver Public Library, Western History Department.)

Sonny Lawson, owner of Radio Drugs, was also known for his political activism in the Five Points neighborhood and among Denver's African-American community. In 1972 the original Curtis Park ball field and park, located at 23rd Street and Welton Street, was renamed Lawson Park in honor of him. At this time, it was the first park to be named after an African American in Denver.

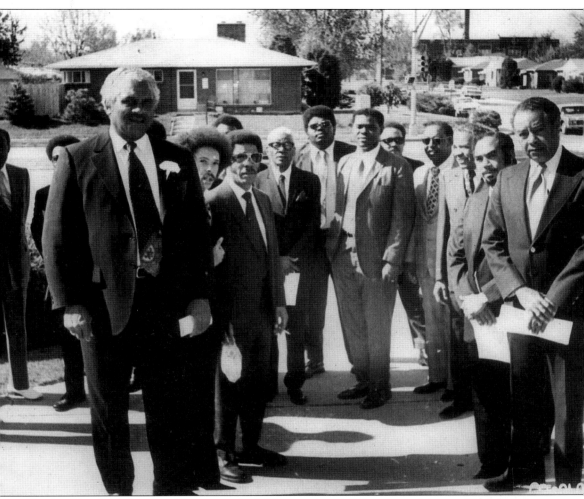

Charles "Brother" Cousins (front row, far left) spent his childhood watching and helping his father, Charles Cousins Sr., build his real estate and construction business in the Five Points neighborhood. For over 30 years, "Brother" Cousins, as many local people call him, has been a licensed building contractor. He continues the values that his father instilled in him by employing people from the community and providing housing and financial support to people who want to further their education or start their own business. Cousins is active in the community on many fronts, and has received numerous awards for his service to the neighborhood and throughout Denver. (Courtesy Denver Public Library, Western History Department, McCloud Collection.)

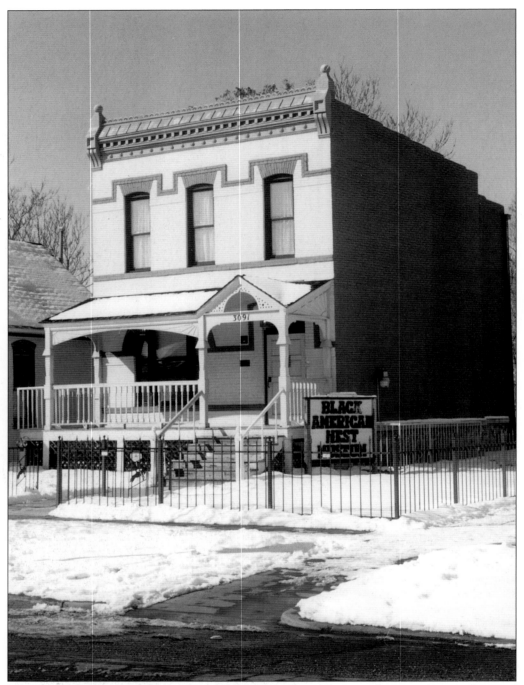

In 1984, the Justina Ford Home was moved to California Street to become the new home of the Black American West Museum. The museum features the history of Black Americans from throughout the West and includes displays and information regarding African American cowboys, business people, physicians, military heroes, entrepreneurs, and many more important black figures throughout the western United States.

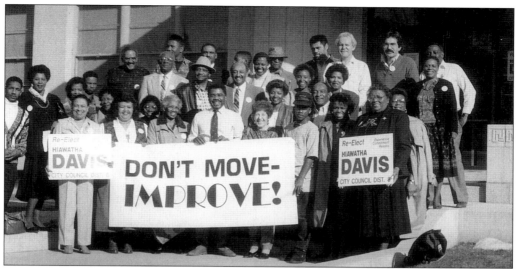

Hiawatha "Hi" Davis was a Denver native who dedicated his life to human and civil rights. For 16 years, Davis served on the Denver City Council representing District 8, which included Five Points. In September of 1999, Davis stepped down from his City Council position to serve as Director of the Mayor's Office on Human Rights and Community Relations. Unfortunately, Davis passed away on May 24, 2000, after battling prostate cancer. According to Mayor Webb, Hi was "simply a remarkable human being who held a great degree of love and respect in the community." In this photo, Davis (front row center) stands with leaders from District 8 neighborhoods who supported his re-election and his motto "Don't Move – Improve." (Courtesy Denver Public Library, African American Research Library, Hiawatha Davis Collection.)

Colorado State Senator George Brown (left), Colorado State Representative Daniel Grove (middle), and Colorado State Representative Isaac Moore (right) walk down the hall at the Colorado State Capitol Building sometime between 1964 and 1968. All three fought for civil rights in the form of legislation that included fair housing and open-records laws, fair employment bills, and prison work release programs. They were also active members of the Five Points community through organizations such as the Glenarm YMCA. George Brown went on to become lieutenant governor of Colorado from 1975–1979. (Courtesy Denver Public Library, African American Research Library, Isaac Moore Collection.)

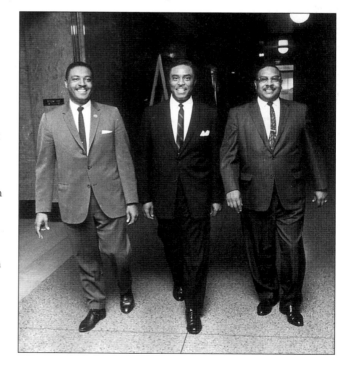

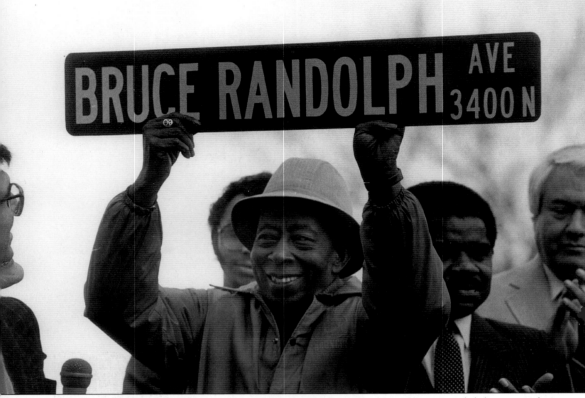

Five Points restaurant owner and local philanthropist "Daddy" Bruce Randolph is seen here holding up a street sign that bears his name during a dedication ceremony in 1984. Randolph donated thousands of hours and dollars to provide clothing and holiday meals to the homeless. His Thanksgiving meals were provided to more than 20,000 people annually. Also seen in the photo are former Denver Mayor Federico Peña (on left) and the late Denver City Councilman Hiawatha Davis (on right). (Courtesy Denver Public Library, African American Research Library, Hiawatha Davis Collection.)

Seven

REBIRTH
(1990–PRESENT)

THE RENEWAL OF THE
FIVE POINTS NEIGHBORHOOD

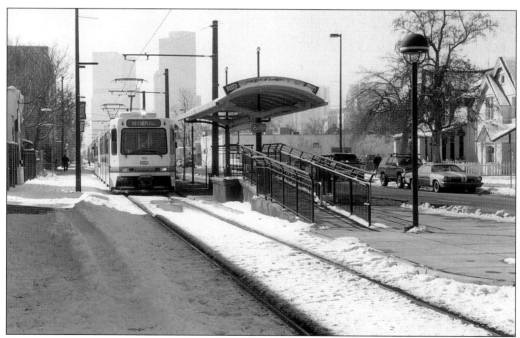

The streetcar system continues to travel through Five Points today. Opened in 1994, the Regional Transportation District's Metro Area Connection (MAC) light rail line runs from 30th and Downing directly through the Five Points Business District along Welton Street, continuing to downtown Denver and out to I-25.

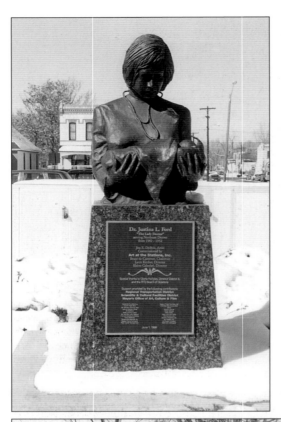

In the summer of 1998 this sculpture of Dr. Justina Ford was dedicated as part of the Art at the Stations Program at the Five Points RTD light rail stop. Designed and sculpted by local Five Points artist, Jess E. DuBois, the bronze statue portrays Dr. Ford caring for a newborn child.

Charlene's House of Beauty has been located in Five Points at 2802 Welton Street for over 50 years and offers cosmetics, skin care, and hair salon services for the whole family. Charlene Jordan moved to Denver from the south when she was a young woman to open her hair salon, which continues to serve the community.

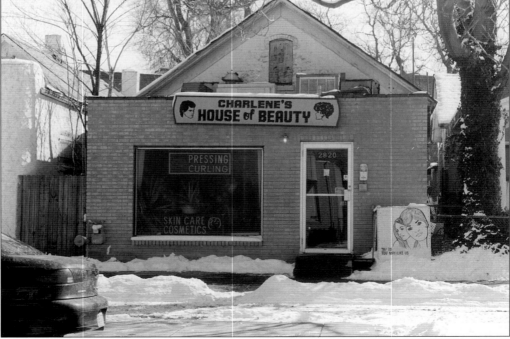

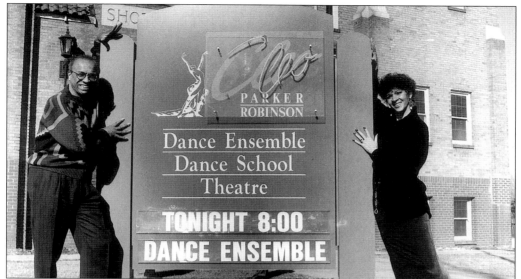

Founded in 1970 as a grass roots organization, the Cleo Parker Robinson Dance Ensemble has grown into an internationally acclaimed multi-cultural dance-art institution. The organization is composed of a professional dance ensemble, dance school, in-school lecture demonstration series, international summer dance institute, and an outreach program for at-risk youth. In this photo, Cleo Parker Robinson (right) and Donald McKayle, modern dance choreographer, stand beside the sign in front of the studios. (Courtesy Cleo Parker Robinson Dance.)

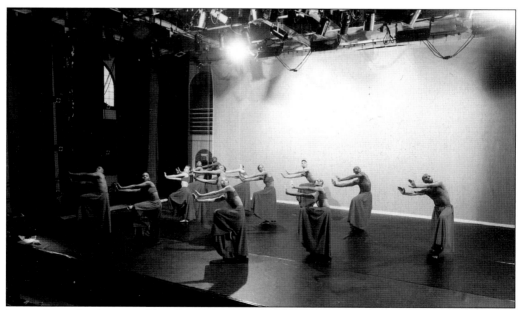

Located in the historic Shorter AME Church, the Cleo Parker Robinson Dance facility includes a 300-seat theater, dance studios, and administrative offices. Here, members of the internationally renowned Cleo Parker Robinson Dance Ensemble perform modern dance on the stage where the altar of the church used to be. Original pews are still used as seating for the theater. (Courtesy Cleo Parker Robinson Dance.)

The first African American to be elected mayor of Denver, Wellington Webb (standing left) is currently serving in his third term. A Denver native, Webb has a long history of public service. His past positions have included Colorado State Representative (representing his boyhood home of Northeast Denver), Regional Director of the Department of Health Education and Welfare, Executive Director of the Colorado Department of Regulatory Agencies, and Denver City Auditor. He is president of the National Conference of Black Mayors, immediate past president of the United States Conference of Mayors, and serves as vice president for the National Conference of Democratic Mayors. He has been selected by *Newsweek* as one of the top 25 mayors in the country, and for the past six years has been voted one of the 100 most influential African Americans in the nation by *Ebony* magazine. While under the leadership of Mayor Webb, Denver has been cited as one of the top five American Cities by *Fortune* magazine and *Money* magazine. (Courtesy Denver Public Library, African American Research Library, Mayor Wellington Webb Collection.)

Established in 1992, the Five Points Media Center Corporation acquired a vacant building on the corner of 29th and Welton with the idea of turning it into a media and telecommunication center for the community. By 1994, the building had been transformed into what is now the home of Denver Community Television, public radio station KUVO 89.3FM, and public television station KBDI-TV Channel 12. The Five Points Media Center Corporation has a long-term commitment to the public good through telecommunications. For example, it has been the recipient of many awards including a special Emmy Award for use of media for positive social change. In 1998, the Five Points Telecommunity Network, one of the few in the country serving a low-income community, was launched. Eight sites, including a church, public school, public library branch, public access station, business association, and a housing agency are equipped with state-of-the-art telecommunications technology to address community problems.

The Five Points Business Association was established in 1965 as an agency that focuses on business development and community restoration and development in the Five Points area. The organization provides information and assistance to residents who aspire to start a business, or who are already in business. Help and advisement are offered in many forms, including dealing with licensing and regulatory agencies, and expert assistance to business owners with accounting and marketing.

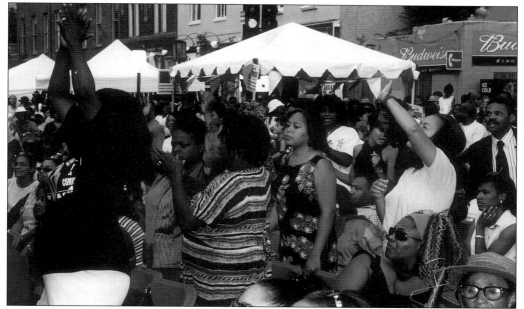

The Juneteenth Celebration continues to be an annual tradition in the Five Points neighborhood. Today, the festival attracts more than 200,000 people over four days and includes a parade, music, food, African American art, and the crowning of Mr. and Ms. Juneteenth. In this photo, spectators enjoy a live musical performance. (Courtesy Five Points Business Association.)

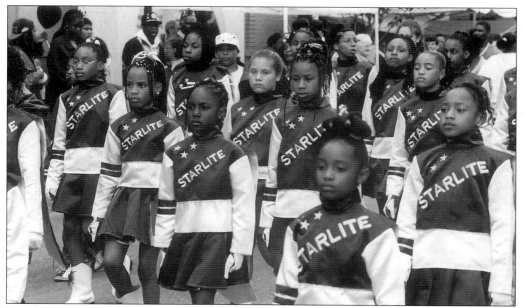

The Juneteenth Celebration is coordinated by the Five Points Business Association and is sponsored by numerous Denver businesses. In this photo, young girls in the Starlite Club concentrate on coordinating their steps while marching in the 2000 Juneteenth Celebration parade. (Courtesy Five Points Business Association.)

The Five Points Plaza was built in the 1980s with funding from the Mayor's Office of Economic Development as part of the revitalization efforts for the Five Points business district. Today, the plaza has a branch of the Denver Motor Vehicle Department, which brings people to the area from all over the city, as well as an insurance agency, gift shop, restaurant, and eye care center.

Five Points is being recognized as a great place to experience urban living and the demand for housing is increasing. This project combines the renovation of a historic building with the construction of a new structure. Located at the corner of 24th and Welton Streets, construction is scheduled for completion by fall of 2001.

Coors Field became the home of the Colorado Rockies baseball team in April of 1995. Located in the Lower Downtown district, the main entrance to the stadium is located at 20th and Blake Streets. Drawing record crowds since its opening, Coors Field has had a significant impact on the areas that surround it, including Five Points. Changes such as an increase in housing and commercial projects, infrastructure improvements, and a growth in tourism, have brought prosperity to the area that is spreading east towards the Five Points neighborhood.

New interest by people to live in downtown Denver has brought a surge of development in the form of newly built housing as well as renovation projects to Five Points. This old building, located at 33rd and Blake Streets, was once an industrial and sugar machinery building, but has been renovated into market rate loft condominiums. Commercial projects are underway in the neighborhood as well, helping Five Points to become the thriving business and residential area that it once was.